American Premium Guide to

OLDE
CAMERAS

Identification & Value Guide

by David Sharbrough

BOOKS AMERICANA
INC

771. 3075

ISBN 0-89689-037-6

Cameras-Collectors and collecting

Introduction

In introducing this volume, I'd like readers to know that over 15 people assisted me in one way and the other in writing and preparing the work, and encouraging me with the biggest short sentence, (for a writer, anyway) in the English language: "Don't quit Now!".

Over the past five or so years, I've written perhaps twenty short and long articles on collectibles, ¾ of these on the subject of rare and vintage cameras.

But thinking you can 'snap out' a full-length book on this basis, is like believing you are ready for Saturday Night Fever because you can do a fair version of The Lindy Hop in front of a mirror!

The first thing, really, is the Bigness of the whole thing — There are an estimated 3,000 separate models and versions, of over 500 different brands.

And the subject of prices is a bit mind-boggling in itself. A lady from the Midwest wrote me: "I am selling my Argus C-3. I paid $35 for it 30 years ago, and I would like to get my money out of it!"

I pushed aside my two Argus bricks that I paid $5 each for, and opened another letter:

"I am willing to let go of my old German camera for $20 if you'd be interested. It is spelled 'C-O-N-T-A-X. The shutter does not seem to work too well."

I bought the latter camera, and traded it for another camera worth from $100 to $130!

As Kurt Vonnegut used to say: "And so it goes!"

Leicas have been a favorite of mine; I've bought and sold about 40 in the past 6 years, and my present 5 were purchased for from $45, (slow speeds don't work), up to $110, (a mint 111-A from 1936 with excellent lens and case). So it's a mystery to me why cameras identical to mine show up in big-store showrooms for $150 to $399!

But it's no good being mercantile — you have to love your subject. I get a kick out of the old things: My Thornton Picard takes sharp 6 x9 centimeter pictures 50 years after it left the factory. My little Spartus 35 has a built-in yellow filter when you thumb a tiny dial. A Gamma camera from Italy has a shutter made of curved alloy steel.

A 'part of the game' is lost opportunities — I passed up a Tessina 35 miniature for $40 in '79, and today these go for $125 to $300 or more! In 1980, I didn't have $69 for a Zeiss Kolibri — saw one this Winter for $250 in New York!

And the Places you find cameras! Salvation Army stores, flea markets, garage sales for the Lithuanian Social Club — and of course, Willoughbys and Camera Barn and Oldens in New York City!

Before World War Two, America was making the excellent Kodak Medalist and Ektra, and the Germans had a light meter built into one of their cameras — the Contax III!

After the war, American production of fine cameras continued, but we were not in the front running. The Germans and, after around 1948, the Japanese, were making the innovations. But we scored a big one when a certain Dr. Land put his instant-picture Polaroid on the market in late 1948!

And so, we are at the present day. Cameras are, partly, powered by the sun (the Ricoh of Japan), and instant cameras pour out from three firms in America, and even the Chinese are now selling their imitative but well-made cameras around the world. America has the edge in the up-coming field of video cameras, which will display your snapshots on your TV screen!

But they all started from those crude little boxes that froze and captured so many smiles, and grimaces, and tears.

We owe those photo pioneers, sweating to coat plates and focus beneath their clumsy black cloths, a debt of gratitude.

How To Buy and Sell

In buying and selling cameras and photographica, it's well to remember that, like most mechanical collectibles, cameras are not all **that** popular, and so you are not likely to find many in the run-of-the-mill antique stores or flea markets.

You'll probably find:

1. Many, many Polaroids of the 1960's. Metal bodied models from 1948-51 or so MAY be worth $5 to $8 in the "average" or "good" condition. The 95 is common, the 80 models VERY common . . . look for the sophisticated 110 and 120 models. I've bought a 120 Polaroid for $25, sold it months later for $45, while my metal 700 is STILL for sale at $6.

2. Instamatics by Kodak, others. These 126 and 110 film candids are worth at most $5 in barely functioning shape, with case.

3. Argus "35" and Argoflex and Ciro "35" and Ciroflex and Kodak Signets and "35s", others. These are mostly 40's and 50's, mixed metal and plastic construction, and can take decent pictures, especially the little Signet "35". The Falcon 127 and Detroit 127 and Univex Roamer fall into this category . . . flea markets offer these from $6 to $15, while you may find them for $10 and up, while antique stores will try to get $15 to $30 — the last too high, except perhaps for a Signet or a Cirflex TLR or Argus C-3 or C-33 IN CASE,

and perfect working condition, with maybe a few filters and instruction booklet, etc.

4. Lucky Finds. These are many, and rarely found. Let me just give you a sample of my own discoveries:

A Univex Mercury, found in a Salvation Army store, bought for $17.50. It included case, sunshade, 3 filters and an instruction booklet. It was a "II" model, in perfect shape, and 6 months after buying and putting 4 rolls through it, I sold this odd 35mm camera for $25 at a big-city 'swap meet'!

An Ihagee Parvola 127. This 30's model is moderately rare, and worth more than the $10 I paid for it. The shutter was 'tired' — but worked at 1/25th second and faster, and I sold it for $30 a week or so later. An indoor flea market south of Atlantic City, N.J. furnished this small find.

A Ricoh Twin-lens reflex. From circa 1951, this example also had a sluggy shutter, but it freed up after I worked it about a dozen times! For $8, I couldn't complain, and I sold this for $15 months later.

An Italian Gamma 35. This rare rangefinder is a 1950's Leica look-alike, and well-made. The lens aperture was stuck at wide-open, and the metal shutter did not always fire! But from a $39 purchase price, I traded it for another camera worth about $90 to $120 in value!!

A Contax I, variant I. This early 1932 camera was in only "fair" to "good" shape — shutter was totally kaput. A rural antique shop had this gathering dust, and from $30 price, I traded this also for a $100 camera.

An Ernnman Chronos folder. I bought this for $35 — and STILL have it, though it's worth about $45 or so ($60 Mint). A good buy, overall, but not very profitable.

Now, moving up a step, we come to the big city stores, in places like New York, Philadelphia, and about any large city, especially capitals. Most stores have a Used or Collectible section, from a half-dozen forlorn examples, up to a place like Oldens or Camera Barn in New York, which can boast over 150 vintage and collectible cameras under one roof.

A Leica A with Elmar lens, in Very Good condition at best, marked with a $700 price tag! I can buy this same camera at any Swap Meet where collectors congregate, for $395 to $500.

A Thornton Picard Ruby Single-lens, in 3 x 4 inch film size. This 1940 or so minor English classic was priced at $290 at a dealer in New York, while the example I bought from a fellow collector in Norwood, N.J. only cost me $100, and is in Excellent condition!

A Zeiss Maximar folding plate camera, in Fine or Excellent condition, with case, often goes for $100. But my own example only cost me $35 from a fellow collector.

Canon. These are often over-priced — their quality leaves much to be desired in early (1950) models, and they commonly are 'offered' for $100 to $125. I had to chuckle over my own model "IIB", which set me back $50, from a newspaper want ad! Of course, the P and V-T models and the 7 are worth much more.
$350 some posh stores charge!!

A good periodical to buy from is:

Shutter Bug Ads . . . P. O. Box F . . . Titusville, Fla. 32780.
Prices range from High to Fair retail to Low, depending on the individual sellers, who range in the hundreds in a single issue! Subscription is 3rd class, $10 a year — or around $2 for a sample issue.

Generally, camera collectors and sellers are honest and fair people . . . BUT buying by mail, sight unseen, can always be a little risky! Avoid cameras described as "nice" shape, or NO mention of condition — you may wind up with an expensive door-stop! Most sellers will offer a 10 day Money Back Guarantee (MBG) or 10-DRP, (Day Return Privilege).

Pricing is always difficult. While I've bought $100 cameras for $10 to $20, I try to keep my prices in a median range, knowing that, with cameras and photographica condition is VERY important. After all, you probably wouldn't buy a Rockwell-cover Post with a big, black hand-print in the middle, or a Nippon dinner plate that was cracked in half! But this would correspond to a camera in Fair to (marginal) Good shape, that might have a stuck or worthless shutter, dented body and scratched and deteriorating lens! A camera or even light meter or lens that's been dropped off a truck — and looks it — is not much good to anyone, unless it's a rare source of parts! On the other hand, a 20s vintage Ermanox from Germany with stuck shutter and 'gone' leather and no lens would still be worth at least $50 or more, just for the "scavageable" parts, like lens flange, intact body and wind-knobs, etc. On the other hand, I'll probably NEVER sell my 3 x 4

(1939) film size Speed Graphic, for $12, that MUST have been dropped off the Empire State Building — probably by King Kong! Speeds are just too common!

When mail-buying, hold out for Very Good or Very Good plus or better condition — and 10 day MBG!!

Photographica includes so many things — flash units, enlargers, books and back-date magazines and hardback annuals and catalogs, light meters and on and on.

I like books and annuals. Generally, I value by quality, rifling through the book, and by age. After all, a magazine edited by Alfred Steiglitz from the early 20's is bound to be far rarer than a hardback book of the 30's or 40's or 50's. Again, taste determines — volumes of nudes from the 1950's would go fast with some collectors, who could not care less for an 1890's circa EH Anthony catalog, showing views of printing frames and view cameras — though the latter is probably worth more!

Look for books authored by the Greats of Photography — Margaret Bourke-White, Ansel Adams, Bernice Abbott, Steiglitz, etc., etc. Jacob Deschin was an excellent photographer . . . but he wrote a LOT of books and his works are not that rare. Kodak company books are also very common. On the other hand. U.S. Camera Annuals in Very Good shape and hardbound are collectible, and the early 1950's Naked City by WeeGee is a prized volume, though not the later, poorly reproduced re-prints in softback!

I don't want to get into specific values in this area — enough material for a 150-page book in itself! As for enlargers, I don't want to touch 'em! The old Elwoods and Solars and better Kodaks and others are pretty to look at, but ask yourself — what would I DO with a 5 x 7 (or whatever) enlarger that stands 3 ft. and can weigh over 35 LBS!!!?? Similarly, many older flash units are made of chrome, finely finished — but can you use them on YOUR camera? — probably not!

I stopped with my 1949 Kodak (Ektar lens) enlarger, for $25 — but it took over one-third of the prints in this book. For once, I was lucky!

On Buying Cameras By Mail

Very often, buying by mail can mean cheaper prices. It also means you're buying blind. But the words in the ad can often tip you off to what you MAY be getting:

"Old box (or folding) camera" . . . It may mean you will be asked to buy a 1937 Ansco Shur-shot, that is rusty, not rare, — and you'll be asked to pay 10 times what it's worth! Call first, ask the seller to read the name, or any other data on the body.

"1920's Whizzbang folding camera. Rare antique. Best offer." Again, call the phone number, ask for details! A real camera-nut would know a knowledgeable buyer rates cameras by NAME, not fancy adjectives!

"Lully-Escagot French stereo camera, from 1899. Has a few parts missing. Best offer" . . . NOW we're getting somewhere. This person probably knows a bit about cameras. For example, WHAT parts are missing? . . . Two screws on the body, or a viewfinder, or the whole lens/shutter board???! CAREFUL on this!

"Squashflex SLR, made in Austria, with spare Angina Pectoris spare lens, Mumbly add-on filters, in fatted calf fitted case." . . . OO Boy! Sounds like a retired camera-store owner, or a guy who once shook hands with Daguerre himself. Might be a good buy . . . if you don't mind paying for all those 'extras'!

"Old black camera, owned by my father, used in last 99th Dragoon stand against the Fuzzy-Wuzzies . . . " Actually, it may be a good camera (say, seriously, a Soho single-reflex, Dallmyer lens and roll-film back) or it could be a scruffy Ica-Houghtons candid camera with bullet holes in the bellows! The Soho would be worth $100 and UP, while old Houghtons in beat shape can be picked up, circa $9 at camera shows! Again, — call and investigate. And remember that cameras with Memories attached may be worth a LOT to the seller in sentiment. Do YOU feel like paying for sentiment?

"Rolleiflex TLR with case, Tessar lens, from 1930's. Used a lot, still in good shape. $50." Now, this person probably knows his cameras. It's a good buy. The ad is factual, no "antique" ballyhoo, and you know you could re-sell it for $40 to $80.

Some terminology:

"10 Day MBG . . . Means Money Back Guarantee, as does DRP, (Day Return Privilege).

"ST, X Synch, RF, EKC" These abbreviations mean, in order: Self-Timer, Flash synch for strobe flash, range-finder, and East Kodak Company.

"F, P, G, VG, E, and M", these mean condition: Fair, Poor, Good, Very Good, Excellent, Mint. "F" for Fine is coin terminology, not cameras!

"CFH, FPA, WA, W/lB, PP, CCR, and BO" These mean: Cut Film Holder (also Sheet Film Holder), Film Pack Adapter, Wide Angle, Postage Paid and Check Clearance Required (do yourself a favor, send a PMO or Postal Money Order). And finally, BO means Best Offer.

Some tidy people like to abbreviate the names of cameras, too: FPK means Folding Pocket Kodak, and ROC is Rochester Optical Company. But MOST people spell out the name — an ad is not a telegram!

By far, most camera sellers are honest. BUT . . . it is definitely your fault if you don't want to spring for the $1.25 to $3.00 or so for mailing insurance, and your collectible camera comes to you looking like the Jolly Green Giant and Pele used it for a soccer ball!

And don't expect that a "Fair" condition camera you ordered will come to you looking like a museum piece! Poor and Fair mean WELL-USED and often ABUSED. Myself, I won't buy anything that's advertised as less than VG+, (Very Good Plus).

Lecture's over, folks. Good hunting!

ADAMS & CO. of London

THE MINEX, Single-Lens-Reflex, 1895 to ? Large, heavy woodbodied classic, similar to the American Graflex. Came in 2 x 3 and 3 x 4 inch film sizes. Smaller 2 x 3 value $235 to $545; 3 x 4 from $175 to $235. This camera has a good, strong focal-plane shutter — expensive to fix if non-working!

YALE DETECTIVE, came in different models. The Yale used glass plates, bellows to focus inside a rectangular boxy body. No. 1 is a cheap model, Nos. 2 and 5 better. Value $60 plus for No. 1, No. 2 about $140 to $200, and No. 5 stereo, $390 to $475. If there are Nos. 3 and 4, only the British know for sure

ADAMS & WESTLAKE, Chicago, Illinois

Adlake Plate, came in 3 x 4 and 4 x 5 sizes, vintage 1898. Has a sliding knob on top of body and large view windows, and a side-opening door for loading. Value $50 to $75. Adlakes have gone as high as $120 in perfect condition, with fitted leather case.

ADOX, Weisbardan, Germany

Models include the 35 mm Adox Ca. 1936, a post-war Aorette, also 35, and I've run across a few 120 roll film models called Golf and Sport, Aorette, valued at around $35, others about $20 to $25. No excitement here.

AGFA (later AGFA-ANSCO, Today GAF Corp.) Munich, Germany

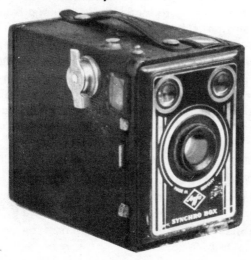

AGFA Box
$5 - $10

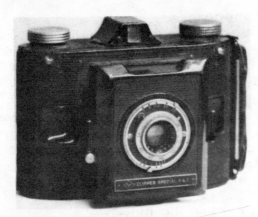

AGFA Clipper Special
Photo by Bruno DeGrassi
$7 - $15

AGFA (later **AGFA-ANSCO,** Today **GAF** Corp.) Munich, Germany
AMBI-SILETTE, a nice, well made 35mm with replaceable lenses and no range-finder. This 1967 to ? camera was not a big seller, but compur shutter and excellent lenses make it a good buy at $60 to $110. Extra lenses valued from $25 to $65. A complete outfit, all lenses, flash in case ? . . . value $185 plus.

AGFA BILLY and **RECORD,** folding cameras using 620 or 120 roll film. Common, but worth having. Value $10 to $30.

CLIPPER & CLIPPER SPECIAL, post-WWII metal candids using obsolete 616 film. $7 to $15.

ISOLETTE & ISOLETTE SUPER, using 120 film, compur shutters add value. Super valued at $50 plus, regular models $15 to $25.

AGFA KARAT, models called 12 and 36. Front with lens pops out. Made from 1936 into the war, and some years after. The "12" is worth $20 and up, the nicer "36" goes for $25 to $45. Film advance is by small metal lever on right side of camera!

MEMO, two very different models. The Memo I looks like a giant cigarette lighter, historically interesting as a 1927-model 35mm camera! A tubular view-finder is atop the body, and tiny metal carrying strap. Shutter on this model is often 'gone'. Value $35 to $55. The squat-bodied Memo 2 has a fold-out door, and curious film-advance lever on back. This 1939 to ? 35mm camera is valued at $45 to $65.

AGFA PD-16, PLENAX and **READYSET,** these 620 and 120 roll film models are 50-50 collectibles. $7 to $15.

SELECTA, a 1960's 35 using built-in meter. Rare, using Solinar lens. Check meter on this one! Value $55 to $110 — if it works!

AGFA SOLINETTE and **SILLETTE,** 35mm with Apotar lenses, made from late 30s to 1950's. $15 to $30.

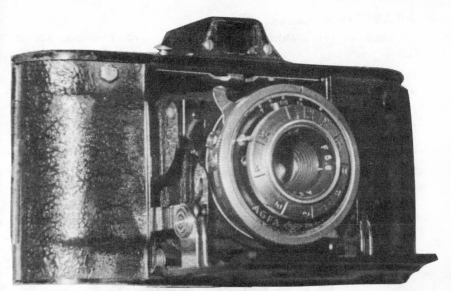

AGFA Memo ca. 1938 $45

STANDARD, made in 1930's, uses cut film and old 616 roll film. Value $15 to $30.

AGFA VIEW, these made from wood, and nickel or brass trim — nothing fancy. Various lenses and shutters, made from late 20's on. $35 plus.

AIR KING

A very curious 120-film camera **and** a radio in one body, a poorly-constructed curiosity, but rare! Value $95 to $115. Check working condition and appearance of phony "lizard skin" cover!

AIRES

All are post-war "35's" from Japan in the 1950's. Good products, nothing to write home about. Model IIIL - $40 plus. Model 35V - $60 plus. Airesflex TLR, slightly rare - $40 plus. Viscount 35 - $30 plus.

Kalimar Aires V
$25 - $50

13

AKARETTE & AKARELLE

"35" cameras from Freidrichshafen, Germany. 1950's vintage. $25 to $45.

AKAREX

A 35mm range-finder from Germany, from the 1950's. The lens and finder are changeable as a unit in this well-made but very odd camera. A useable collectible valued at $100 to $140.

ALPA

A beautiful Swiss camera by Pignons. The original 1940 Model 35 used a small penta-prism **and** range-finder. Focal-plane shutter goes to ⁻/1000 of a sec. Value about $235 plus. Other models numbered 4, 5, 6 . . . etc. Made to the 1970's. Model 7 value $120 plus; Model 9D with light meter - $210 to $245.

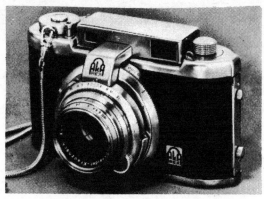

Akarex "35" $100 - $140

ALTISSA of Dresden Germany

ALTIFLEX, from the depression 1930's. This Twin-Lens-Reflex is well made, using various lenses. $20 to $35.

ALTIX, a post WWII 35mm. Some models feature a cloth focal plane shutter, and interchangeable lenses, but poor workmanship sets this curious camera down to $25 plus value.

AL-VISTA, made by Multiscope Co. of Burlington, Wisconsin

A panoramic camera was made 1892 to ? , on roll film. The tiny lens swivels out of a cloth "muffle" on camera's front. Models include 4B, at $185, 5B at $185 to $240, and 5D at $205, while a "convertible" 5F has a regular **plus** panoramic front — rare, and valued at over $400!

Al-Vista Panoramic, takes 180° exposure, ca. 1896 - 1901 $185+.
Courtesy, John Groomes

AMERICAN CAMERA CO.

Also called **BLAIR CAMERA CO.** These early models of American Cameras were called Buckeye, in Nos. 1, 2 and 3. These 1895-vintage wooden folders often have handsome leather covering, red bellows, and nickel and brass hardware. Good-looking vintage products, and uncommon. Values — No. 2, $55 plus, No. 3, $60 plus and "No. 1 Tourist" $80 to $120.

AMERICAN OPTICAL CO.

Later became part of "Scovill Co." Early, finely made models include Henry Clay Camera, 1896, using 5 x 7 cut film — $280 plus. An 1898 Klondike model used a simple lens and shutter for 4 x 5 film. Value about $55 to $75.

AMERICAN SAFETY RAZOR

This rare "ASR Foto-Disc" used a disc of film, sliding into focus behind a simple stationary lens. This 1950 to ? little strange-o is very rare! A lucky collector once found one at a Salvation Army sale — for $20, but "real value" would be over $200, with a high of $400 plus to a fanatical 'specialty' collector.

15

ANSCO of Binghamton, N.Y.

ANSCOSET, 1950's vintage range-finder "35", with a built-in meter! so-so quality, but worth $25 plus.

AUTOMATIC model, this 1924 to ? **Motor-Drive** camera used a spring winder to advance its 2 x 2 inch roll film! Outside appearance like many other folders, but rare. Value $140 to $240.

AUTOMATIC REFLEX, called Finest American Twin-Lens, this heavy 1947 to 50 TLR has a -/400th second shutter, and 1949 brought flash sync! A useable and rare 120 film camera. Value $70 to $175.

BUSTER BROWN — A wide range of folders, made from 1910-1920. These are well made, but not unusual, a good beginner's collector choice. Value from $5 to $10 to $15.

GOODWIN JR., an unusual strut-fold-out camera, named for an early photo inventor. $15 to $25.

ANSCO KAROMAT, a 35mm from 1950-1955. $20 plus.

PHOTO VANITY. A simple camera, but decorated in grey color set in a kit, as a lady's purse! Very rare; values have varied from $120 to $540 and more in recent years. Careful identification called for here!

ANSCO MEMO - See **AGFA**.

READYSET, VIKING, PD-16, SPEEDEX — These and others are simple in design. For automatic models, see AGFA. Others valued at $10 to $15.

VEST-POCKET, similar to Kodak's, but a few I've seen had Tessar and Goerz lenses - value at $20, the others at $15 plus. Identify by struts, and pull-out front. A few had fold-down beds, called Model A.

FOLDING. Various models include No. 1, No. 2, and on and on, up to a relatively rare No. 10 using 342-inch roll film. No. 10 has a $25 plus value, others range from $12 to $30, more for Reo Bellows, of course! These and the cheap 1930's models are what most collectors find in flea markets, etc.

ANSCO VIEW. These 'monsters' show up occasionally at garage sales — a strong back is needed, as they weigh from 4 to 15 lbs! Wide ranging values: $50 to $115 plus, a perfect condition model with Goerz lens up to $150! The 8 x 10 models are still used daily by some professional photographers.

ANTHONY, of Broadway, N.Y.C.

This company merged with Scovill Co. around 1902, and in '07 they became "Ansco".

ARGUS (international Research Co.) of Michigan

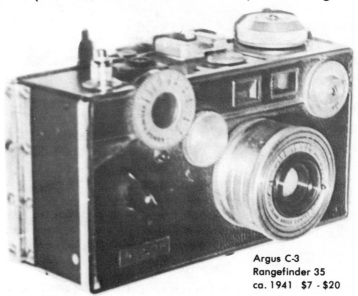

Argus C-3
Rangefinder 35
ca. 1941 $7 - $20

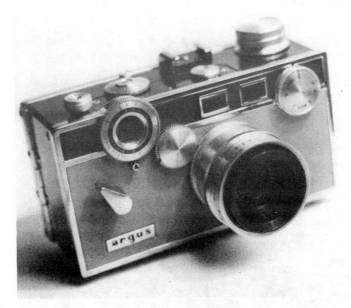

Argus C-3, 50's $7 - $20

Argus "A" 35mm $10+

There are probably a million Argus products still in circulation — a good beginner's choice!

ARGUS A, put a plastic (Bakelite?) body on a simple lens shutter - Grandpa's Instamatic! A few were painted gold - why? Value $10 plus.

AF, AA, A2, A2B, A2F, FA — all similar, though the A-2 focuses to 1½ feet! Values average $15.

Argus A2, 1936 - 50, $15

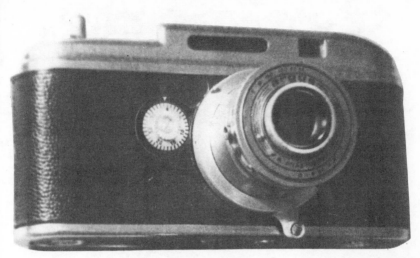

Argus A-3, $25

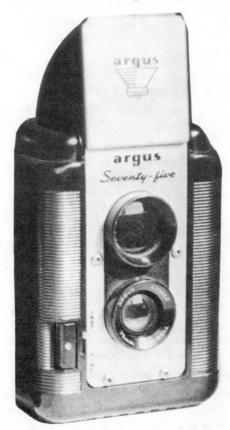

Argus "75" TLR, $5+

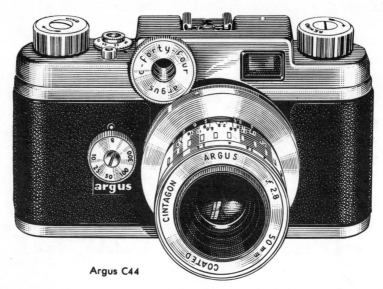

Argus C44

A-3 and **CC**, these have rounded ends, stead of the angular early models. $12 plus.

A-4 and **C-20**, sync-flash on these. $15 plus.

"K", this odd-looking Argus had an extinction - meter coupled to the lens iris! Value $60 to $180 because of rarity.

C and **CC, C-2**, and **C-3**. This is the "black brick". These almost indestructible cameras are sturdy, and — they're everywhere! A C-3 matchmatic came in black, grey and beige. Prices go from $3 to $25.

"21". This 1947-vintage model has sync, also. $15 plus.

C-44 and **C-44R**, have interchangeable lenses. $25 plus.

ARGOFLEX. This twin-lens is metal-and-plastic. Still useable with 620 roll film. 1948 to 1957. Values $5 to $20.

AUTOMATIC RADIO, "Tom Thumb". This is another (1948) radio plus camera! Not much good as either, but rare! Recent prices $55 to $100.

ASCOT

All models of this 1899 vintage camera are well made and rare. Film sizes range 4 x 5 to 5 x 7. Valued at $55 to $85.

BOX MODELS. Few were made, bodies are solid wood, leather covered. $40 plus.

BUCKEYE BOX, date from 1896. Often were 'convertible', using plates or roll film. Values $40 to $70.

KLONDIKE. A plain-appearing box camera, made in small numbers. $75 plus.

NORMANDIE and **NOVELLETTE.** Both were bellows-type, with Normandie made up to 14 x 17 inches in film size! The Novellette is unusual. Bellows and back both rotate, for vertical-to-horizontal pictures! I have seen these with black, brown and red bellows. Normandie valued at $180, while the 1885-vintage Novellette has sold as high as $250!

PDQ, this box camera has two pointer-and-scale adjustments front and side, dates from 1890. Rare. Recent prices: $230 to $330 to (perfect condition with case) $500!

BABY RUBERG

A 1939-vintage roll-film camera, using a simple lens and viewfinder, and helical focusing. Bakelite (?) body. Value, $30+.

BALDA WERKE, Dresden, Germany

BALDINETTE, a 35mm folder from 1937-39, with F 2.8 lens and a Prontor shutter. A 1946 version has PC sync, both use a simple view-finder. Value about $30 plus.

PICCO-CHICK (?) I've never seen one of these, supposed to be interesting little 127-film, mostly seen with a 'Vidanar' lens and Compur shutter. Value: $25 to $35. A **RIGONI** and a **BALDI** model were also built for 127, values might go up to $40 in perfect condition.

Balda 35 mm
1950's
$30+

SUPER BALDINA, SUPER BALDINETTE, SUPER PONTURA. These are 35mm for the first two, and 120-film for the Pontura. All feature coupled rangefinders, hence 'Super' . . .! Values would be similar among them: $20 to $35. Add a bit if any model has the sharp F 2.8 Tessar lens.

BEAUTY CORD and BEAUTYFLEX (actually Taiyodo Koki, Japan)

These late 40's twin-lens reflexes were inferior to the better German and American TLRs — reflected in their $22 to $30 value range.

BECK of London, England

The **FRENA** was a long-body "detective" camera made in 3 film sizes. Featured a high speed of 1/80th second, and slower speeds, plus a fancy model: The Frena Deluxe, supposedly with its metal parts gold-plated! You might run across a Frena someday; value it at $140, and a Deluxe model — just about twice or three times that!

BEIER of Germany

Four models that I know of were made from the 1930's; the Beirette was a 35mm camera rarer than others in the line, look for a Compur Rapid type shutter, and a Beira 35 with F 2.7 lens. Either would be worth over $100, while the folding sheet-film models and a 120 Precisa model would have a $25 plus value, little more.

BELL CAMERA of Grinnell, Iowa

STRAIGHT WORKING PANORAMA . . . this is the only model I have seen. Made about 1908, the wide-angle lens gives a semi-panoramic view without moving or swivelling lens, as other brands. Controls even allowed the owner to increase or decrease format on the roll film! Rare. Value $240 to $385.

BELL & HOWELL Chicago, Illinois

DIAL 35, was a 50's and 60's camera with spring-winding of film, and electric eye. Winder protrudes below camera like similar control on some German Robots — looks like an old potato masher! Well made, worth: $35 to $65.

B&H 200EE, used an electric eye also, but on 16mm film! Historically interesting. Value $30 plus.

FOTON, this 35mm camera tried very hard to be "The Best", with spring-drive motor film advance, and a cloth focal-plane shutter up to 1/1000th second, AND inter-changing lenses by bayonet mount! If

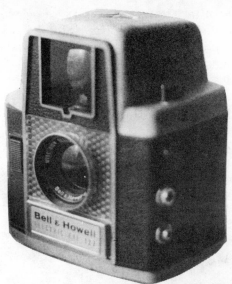

Bell & Howell 127,
"Electric Eye", 60's
$5 - $15

you do someday spot one of these, be cautious — you would need an owner's manual to know how to work the controls! A Foton from 1949 would be worth $235 with non-working shutter but good lens, just for parts, and up to $520 in perfect working condition, with case, etc. VERY rare.

STEREO COLORIST and **VIVID**, these stereo products were originally made by Three Dimensions, Inc. The Colorist is more prized, its 1 200th shutter helping to account for a $145 plus value, while the Vivid could range between $60 and $120!

FILMO 16mm MOVIE CAMERA, vintage 1925. This large but well-made camera had inter-changing lenses, and used a governor-and-spring drive. Value about $30 plus.

BELLIENI & FILS, Nancy, France

This old line company made a "press" type camera, with various lenses and shutters, that may date from 1908 into the 20's . . . value $75 to $140.

JUMELLE, a 9 x 12 plate type camera, and a cousin, the Stereo Jumelle. The 12 x 18 CM Jumelle has a 'panoram' setting. Rare, but if you encounter either: $120 for regular model, and up to $340 for the Stereo, with case.

BELPASCA STEREO, from Belca Werke

Mostly because it has Tessar lenses available, this 35mm stereo from about 1951 is worth: $200 to $340.

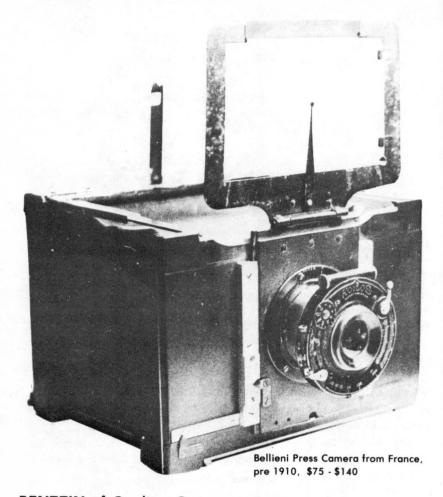

Bellieni Press Camera from France, pre 1910, $75 - $140

BENTZIN of Gorlitz, Germany

PLAN PRIMAR, a folding camera of better-than-average construction, in 6 x 9 and 9 x 12 CM sizes. 1920's vintage; value around $45.

BENTZIN REFLEX, this squarish-bodied camera was a single-lens reflex type, that was also called Primarflex. Using 120-film, the focal-plane shutter went up to 1/1000 second. Like most SLR cameras from the 1930's, however, this fine shutter would cost you dearly to fix!

PRIMAR FOLDING KLAPP. Circa 1920's, this clumsy looking camera shows up here and there, goes for $135 plus.

BERNIG — see Robot

BLAIR CAMERA CO., Boston, Mass.

NO. 3 WENO HAWKEYE, this box type camera is probably the most encountered Blair, vintage 1900. Value: $25 plus.

HAWKEYE DETECTIVE (box), ca. 1890. The leather covered model is worth around $75, both this and the more rare ($140) natural-wood Detective must be examined with great care; many box cameras look like these products, featuring a top-opening door.

TOURIST HAWKEYE, made from 1898 to 1903, this folder has a rectangular wooden front standard, concealing the simple lens and shutter. Value, $120.

BLAIR 6 x 8 PLATE, the oldest Blair product I've ever encountered, (1886), but hard to date since the one I saw had no PD and no number or ident, except the word "Blair Camera" $155 plus.

NUMBERS 3 to 7 WENO HAWKEYE BOXES. These were more "bread and butter" cameras, all leather-covered boxes. $35 to $60.

NUMBERS 3 and 4 FOLDING HAWKEYE. Vintage 1902-03. These folders are mostly horizontal format, with red bellows, and make very pretty 'display' cameras. Worth $30 to $45.

BOLSEY CORP. of N.Y.C.

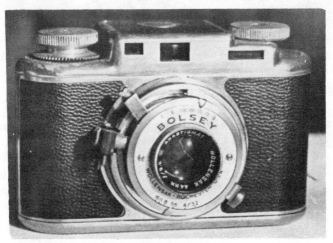

Bolsey "35", $20+

BOLSEY B 35mm with rangefinder. Shutter to 1/200 second. Most common Bolsey. Value, $20 plus.

BOLSEY TWIN-LENS REFLEX, using 35mm film, very compact; unusual design. $35 plus. Also called the "C" model.

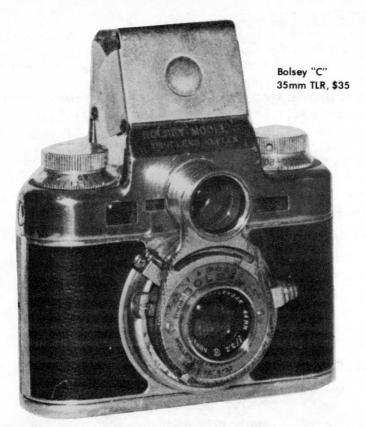

Bolsey "C"
35mm TLR, $35

BOLSEY B-2, U.S.A.F. model. Has Air Force legend on top. Versus $20 plus for an ordinary B-2, the AF version is worth $80 to $100.

BOLSEY JUBILLEE, another 35mm model, more recent than previous (1955). $30 plus.

BOLSEY 8. This slender 8mm film camera can be identified by name on front below lens, and large key on right-hand side. This camera can expose a special cassette of 8mm film through a rotary shutter, for single-shot or regular movie-type exposure. Rare, and well-made. $110 plus. In excellent condition, no tarnish on stainless steel body: $140, with case.

BOLSEY REFLEX 35mm — see ALPA

BOSTON CAMERA CO.

This company MAY have made cameras, or just assembled them — their products, anyway, look very, very similar to Blair and early Kodak products. Most common product: **BULLSEYE BOX.** ca. 1896, $40 plus. A **HAWKEYE DETECTIVE BOX** is rare, uses a brass knob on camera's back to maneuver an internal bellows. $160 to $180.

BRAUN, of Nuremberg, Germany

PAX and **PAXETTE**, these two 35mm candid models, along with a "GLORIETTE" are all compact, so-so in quality, and sold fairly well in America after the Second War. Values range from $15 to $30.

BULLARD CAMERA, Springfield, Mass.

FOLDING PLATE, ca. 1900, this 4 x 5 size camera resembled most others in this era, some models had revolving back. Look for red bellows, brass hardware, as they would add to value. $145 to $180.

BULLARD MAGAZINE. This large and bulky model has a back which can be pulled and pushed to advance the glass plates into focus, and . . . the front drops to reveal a bellows mount lens! Very Rare. $290 plus.

Don't buy any camera that does not have any identification, until you are an expert on collectible cameras. The Bullards above, like many other "small maker" examples, can outwardly resemble many other cameras, worth only $10 to $30. Especially with glass-plate type cameras, it is very hard to tell one from the other.

BURKE & JAMES, Chicago, Illinois

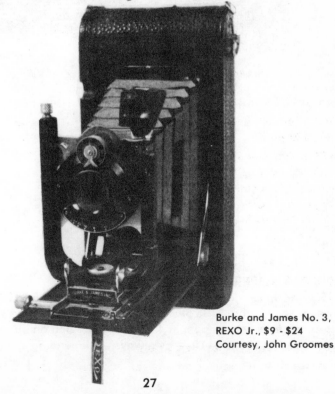

Burke and James No. 3,
REXO Jr., $9 - $24
Courtesy, John Groomes

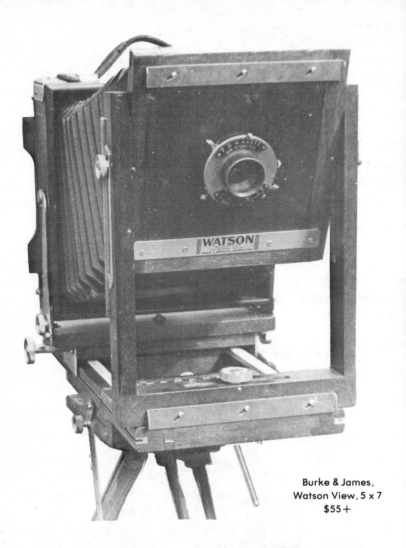

Burke & James,
Watson View, 5 x 7
$55+

IGENTO FOLDERS — in three film sizes, these were a common camera from around 1915 (?) into the 1930's. They are uncomplicated folders, valued at $15 to $35. Any examples covered in colored leather or oilcloth worth more.

REXO — this is a brand name for a half-dozen boxes and folders, values ranging from $9 to $24.

WATSON — there is a fingerprint camera made in the late 20's which I've never seen; value $135 plus. Also many Watson folding View and Portrait cameras were made, in 4 x 5 and 5 x 7 and on up to 11 x 14 sizes. Valued at $55 to $110 — as always — depending on condition.

BUSCH CAMERAS, Chicago, Illinois

PRESSMAN. Various sizes, looks just like Speed Graphic. Dates from 1940's, but has no back shutter like Graphic. $35 plus.

VERASCOPE, F-40. Well-built and rare stereo 50's camera for 35mm. $180 to $340.

BUTCHER, of London. Also Houghton-Butcher

This English company made a wide range of cameras, including a **POSTCARD FOLDING MODEL**, in many sizes, mostly with roll film. Tessar or Goerz lens preferred, naturally. $20 to $45. **CARBINE REFLEX**, a 120-Single Lens Reflex using 120 roll film with simple shutter but good finish, vintage 1922 to ? Aldis lens, or Ross. $130 plus.

WATCH POCKET CARBINE. Another folder, using slightly better lens and shutter than most Postcards. $40 plus.

Other models include **KLIMAX** and **MIDG** models. The latter is a box in many models ($25 plus), the Klimax a folder, ($30 plus). After 1925, the combined firm became Houghton-Butcher, and they continued to make many 'affordable' candid cameras, including a more sophisticated **ENSIGN REFLEX and ROLL-FILM** reflex. The former model has a 1/1000 second shutter. The Rollfilm model has a non-focusing version, value $50 plus, while a focusing model in perfect condition would go for close to $110! As with any foreign Single-Lens Reflex, don't ever try to get one fixed.

ENSIGNETTE . . . this odd-looking folder is more often found than any other Houghtons product. Aluminum construction, leather bellows. This model was made for over 19 years. Valued at $30 plus, up to $45 with Tessar lens and leather case.

ENSIGN MIDGET, this 127 film folder has a simple lens and shutter, dates from 1920's. $25 to $35.

AUTORANGE 220 AND SELFIX . . . Both of these 120 candids were offered for sale after WWII, and used different lens-shutters in combination. $30 to $40.

KLITO, one name for two cameras, a box and a folder. These date from ca. 1915 into the late 20's. Worth $20 and up.

Busch Pressman, 1950's American Newsman's Camera, $35+

CAMERADIO, made by Universal Radio Co.

Around 1949. Used 127 film, with top-mounted reflex viewer. $100 plus.

CAMERA-LIGHTER

Several models of small (2 x 3 inches) cameras with very simple lenses were made in Japan. I have seen these in 8mm and 10mm film sizes. Usually all-aluminum construction, shiny metal finish. High value would be $120, down to only $40. An American product, the 'Camera-Lite' might sell for $180 with original case, in perfect condition.

CANDID CAMERA CORP. . . . see Perfex
CANON

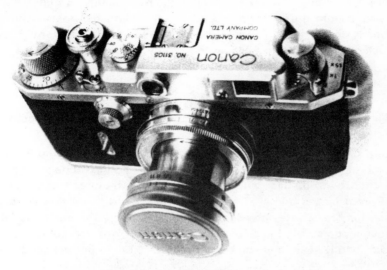

Canon II, Japan 50's, $60+

This large Japanese concern made a long series of 35mm cameras, beginning with the 1937 model. Resembles the Leica line, but has large film-counter dial on front of body, and F 3.5 Nikkor lens. Has sold for $800 to $1,000, because of rarity.

CANON MODELS I, II, III, IV. These came in over TWO dozen variants, with small details identifying each. The early models are more cheaply constructed, often with sluggish shutters. The "IV" is the best of this series, in my opinion, with a rail on body-side for special flash, and a 1/1000th second shutter. All models use Leica-thread mount, and lenses will be marked 'Canon' or 'Serenar'. The Canon is not of sufficient quality to worry about low serial numbers, or such. I value very old Canons at $60 plus, going up to $85 to $100 for III and IV models, to over $140 for a IV's or S-2 in perfect condition, with case. The Canon 'P' and '7' are early 60's vintage, and go for over $155, and are really as much useable professional instruments as they are 'collectibles'! A more affordable Canon from ca. 1960 is the Dial 35, a snap-shooter, value about $30 to $45.

CARPENTIER JUMELLE
An early (1890) camera resembling a binocular, but with angular, all-metal body. Zeiss lenses are usual, and glass plates were loaded from the rear. Values, $120 to $180.

CASCA (Steinheil Corp.)

This very attractive rangefinder "35" was made in 1949, and is quite rare. Interchangeable lenses put it in the high quality category, but it never caught on in the marketplace. A sliding bar to set shutter speeds on the focal-plane shutter is one identifying feature. Prices fluctuate from $180 to $230, with $115 more for all three lenses and fitted case, top around $550 in mint shape.

CENTURY CAMERA CO., New York

This company began life in 1900, was absorbed by Eastman Kodak in 1907.

FIELD CAMERAS, in varying sizes. These ranged from 4 x 5 up to view cameras of 11 x 14 film size. All had wooden bodies, leather-covered. No unusual mechanical features, and many different lenses and shutters were fitted. As with all this vintage, look for brass hardware and red leather bellows of early models. Most models sell for $45 to $85. A very rare stereo model is occasionally seen, and can command over $300 in perfect condition.

CERTO KAMMERAWERK, Dresden, Germany

CERTOSPORT AND CERTOTROP. Both are names of middle 20's to 1930's vintage folding cameras, very similar to many other German models of the same era. Compur shutters and Zeiss lenses are prized. $35 up to $80 in perfect shape, with case and extra film holders.

THE DOLLY is a 127-film compact folder, well-constructed and afford- able at $30 plus.

DOLLINA AND SUPERSPORT DOLLY. Both are 35mm film models from the 1930's, of steel and aluminum construction. Valued at $40 to $70.

"CHARLIE TUNA" Maker unknown

used 126 film. $20 plus, this value is just because of novelty, that attracts collectors. This, and other cartoon-character cameras are worth collecting if you like them, but they do not move on the open market.

CHASE MAGAZINE CAMERA, of Newburyport, Mass.

Vintage 1900, this wood-bodied model has variable lens aperture by Waterhouse, (a small tin disk with holes). Be careful to identify this one, as it resembles other, less valuable falling-plate types. $95 plus.

CHATAUQUA . . . see Seneca Camera Co.

CHICAGO CAMERA CO., of Chicago, Ill.

Various models took direct positive, "almost instant" street pictures. All resemble small suitcases, with a simple lens and shutter mounted in a metal circle on camera's front. Models include Mandel, and Mandelette, and 'PDQ'. Values range widely, from $100 up to $200. For top prices, look for carrying case, and developing apparatus and tripod.

CIRO CAMERA CO. of Delaware, Ohio.

CIRO 35. This candid rangefinder camera is often seen, usually with a Wollensack lens and simple shutter. $20 plus.

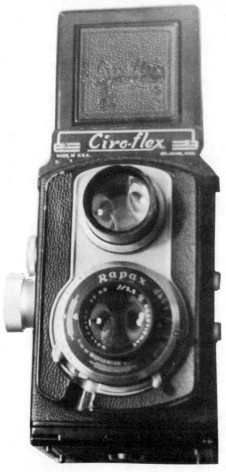

Ciroflex TLR, U.S. ca. 1950, $12 - $40

CIROFLEX Twin-lens reflex. Using 120 film, the Ciroflex is common, and is a good, usable picture-taker to boot. Last model, The "F", has a F 3.2 lens and 1/400 second shutter, and flash sync! The F can go for $40 with case, the others down to $12!

CLARUS

This 35mm tried to make a dependable focal-plane shutter at an affordable price, and failed. So, the ones you will find on the market often do not work. Their solid metal body and unusual design keep them collectible, however, at $15 to $35.

COMPASS, made in Switzerland for Compass of England in 1938.

This very unusual camera had a small, finely finished aluminum alloy body. Besides a rotating shutter going to 1/500 second, the Compass had provisions for right-angle viewing, and a stereo attachment! The camera exposed onto small glass plates that were sold with the camera. A Kern lens and range-finder made it a fine professional instrument in its time, and I have been told that fewer than 800 of the Compass were ever made. You MIGHT find one someday, simply because many people would not even recognize it as a camera! But, while I've known of people who snapped these up for $50 to $125, the real 'fair retail' value would be over $500, with some more for the many accessories that originally came with it.

"CONCEALABLE" CAMERA by Mast Co.

I have never seen one of these; they were supposedly a spy type camera shaped like a pack of cigarettes. Shutter went up to 1/500 second, actuated by a trigger shaped like a cigarette end protruding from camera end! Only prices I have ever heard were $100 to $150.

CONDOR 35 by Galileo of Italy

A neat-looking camera, smaller than most 35s of the period (1953 to 56), $40 to $50 to $110 perfect shape.

CONLEY CAMERA CO. of Rochester, N.Y. Marketed by Sears.

These were best-sellers in the early 1900's, and show up often. An unusual stereo is rare, sells for $100 plus, but most models encountered will be the Kewpie box. (This is a side-loader) that is valued at $20 plus, and various folding models. Most common are the 4 x 5 and 5 x 7 sizes, that go for $30 to $65. Lenses and shutters vary widely; a Goerz lens and Compur shutter would add to value, as would a perfect red bellows and case, and so on

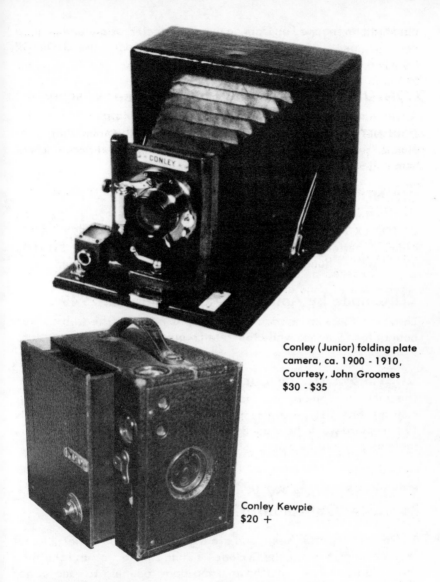

Conley (Junior) folding plate
camera, ca. 1900 - 1910,
Courtesy, John Groomes
$30 - $35

Conley Kewpie
$20 +

CONTESSA NETTAL of Stuttgart, Germany

The Contessa firm was absorbed by Zeiss, so most models
encountered will be from the early to middle 1920's. Many folding
models using cut-film and roll film in 120 are on the market for $30
plus. A small **PICOLETTE** is very similar to the Kodak Vest Pocket, and
this 127 folder is affordable at $30 plus. More expensive models
include natural-wood types called "**TROPICAL**". Often with colored
leather bellows, these rare Contessas usually sell for $280 to $540,

but might be snapped up from an unaware dealer, as a friend of mine once did, for . . . $50! A metal-bodied stereo model is the **CITOSKOP** from the 20's, valued at over $180.

CONTURA, by Stereo Co. of Milwaukee, Wisconsin.

A well made Stereo, 1949 to ? . Valued from $145 plus.

CORONET MIDGET. This English miniature used 16mm film, in a plastic "swirl-colored" body. Simple lens and shutter. Prices encountered: $50 to $10 to $35!

CORNU of Paris, France

Most 35mm cameras by this firm are valued at $25 to $45. An **ONTOFLEX TWIN-LENS REFLEX** is well-made, and this 1939 model is RARE. A perfect **ONTOFLEX** is worth $390. **ONTOSCOPE STEREOS** would sell for hundreds of dollars; I have never encountered one.

CUB, made by American Advertising ca. 1949

This little 828-film camera was really a novelty. The Cub can be bought for $5 or so, while fair retail would be $15!

CURTIS SCOUT by Curtis Color Lab.

This all-metal camera is as large as a Speed Graphic, takes color pictures through 3 separate mirrors and filters inside the body. This 1941 camera would be a good buy at $50 flea-market price, since its real value would be over $380!

CYCLONE, made by Western Co. before 1902, and Rochester Optical after.

These are very often seen, and are a good 'beginners' collectible. Of leather-covered wood, the Cyclones all had simple lens and shutters, most did not focus. Most have a top door, opening to load either plates or serial magazines. Some **WESTERN** models have a large metal key on the body side to release each film magazine, while the **ROCHESTERS** mostly just use two-exposure film holders, also loading by a top door. **MAGAZINE WESTERN CYCLONES** and those by **ROCHESTER** are rarer, values range from $35 to $50, while the more numerous cut-film and plate models sell for $15 to $30! I once encountered a 5 x 7 Cyclone, but most are 3 x 4 or 4 x 5 film size.

Cycle Poco No. 3, for 5 x 4 cut-film, $35+

DALLMYER, of London, England

This firm dates from before 1865, and made wooden-bodied cameras in the late 19th century, which are very rare and costly today. This firm, I've been told, ceased production during the late 1930's.

DALLYMER SPEED. This advanced design folder dates from the early 20's, distinguished by a mahogany body, leather-covered, nickel hardware. Lens standard extends on a wooden bed by scissors-type strutting, and controls to the 1/1000 second focal-plane shutter are on top of the body. Lenses include the prized F 2.9 Dallmyer lens, though I've seen adapted Bausch & Lomb Tessars. Values range from $230 (sticky shutter, torn leather) to over $340 with fitted calfskin case.

DARLING, from Japan

Yet another 16mm all-metal miniature. A 50's product. $40 and up, in working shape only.

DAY-DARK SPECIALTY

Similar to Mandel and other ferro-type cameras, for "pictures in a minute" . . . or two or three. Valued at $85 to $150, depending on condition.

DEJUR

This American firm made projectors and enlargers in the late 40's and 50's, and a candid "35" and a 120 film TLR. The twin-lens-reflex was a good seller, looks just like a Ciroflex. They go for $20 to $30.

DELTA STEREO

This 35mm stereo had a simple lens and shutter, viewfinder. Delta also made a viewer to go with the camera. From $39.95 at Willoughbys in 1955 to . . . $60 plus today!

DEMON Made by Voss of Germany

This tinned-steel camera is only 2¾ inch square. Made in England ca. 1890, the 1-speed shutter was propelled by a rubber band! In appearance, might be mistaken for a kitchen match box. Rare, though one was sold by a small New York shop-keeper in 1979 for $50! Today, a more realistic price would be $440 and up!

DETROLA CAMERA, Detroit, Michigan

Several models had plastic and thin steel bodies, used 127-roll film. These show up all the time, for $10 to $30.

DETROLA 400. This is the one to look for, as it had interchangeable lenses, and a focal-plane shutter. Like the competing Clarus and Perfex, this brand is usually found with scuffed body and 'stuck' shutter. From a lucky Flea Market price of $50, one climbs to 'average retail' of over $180! I've seen perfect models with case and factory flash hit $210.

DEVIN COLORGRAPH

Another multi-filter and mirror early color camera. Rare, bulky, and NOT easily re-saleable! $200 to $310 or so. Goerz lens helps value.

DEVRY QRS

From the 20's comes this early "35", but its Bakelite body (often heat-warped) and simple lens and shutter were NOT an inspiration to

Oscar Bernack and the Leica gang, or anyone else! A side-mounted metal film advance is usually missing! I've seen prices from $35 to $85.

DIAX 35
This '48 or so vintage camera did not sell well, despite Xenar or Xenon lenses. $25 to $45 value.

DOSSERT CO., New York
A wooden-bodied ca. 1891 detective camera is rare. $230 to $435 or more.

DUCA
An odd-ball "35" that looks just like a mini-movie camera, ca. early 1950's. Values, $50 to $90.

DUCATI 35
Italian rangefinder from the 50's is well-made, seldom seen this side of the Atlantic. Focal plane shutter to 1/500 second. Models from 1938 are rarer, include a half-frame model. Prices encountered: $85 to $235.

DURST 66
Post-War 120-film model. $45 and up.

DURST AUTOMATICA. This "35" was well-made, rare today. Built-in light meter. $110 and up in value.

EBNER
German-made late 20's, 120 folder is rare. $115 plus.

EBONY 35
Made in Japan in 1952 or so, simple lens and shutter, valued at around $15.

ECHO
Another Japanese miniature, but made to closely resemble a cigarette lighter. From '53, this 8mm film rarity can go from $55 up to $180.

EHO, (Hofert Wek of Dresden, Germany)
JUWELL ALTISSA. A non-focussing Twin-lens, like Brilliants and cheap Argoflexes. $15 and up.

EHO BOX. Metal bodies box, for 127 film. Value, $35 plus.

EHO STEREO BOX. Simple construction, ca. 1933. For 120 roll film. Prices encountered, $55 to $80.

Elca II, "35",
German, $30+

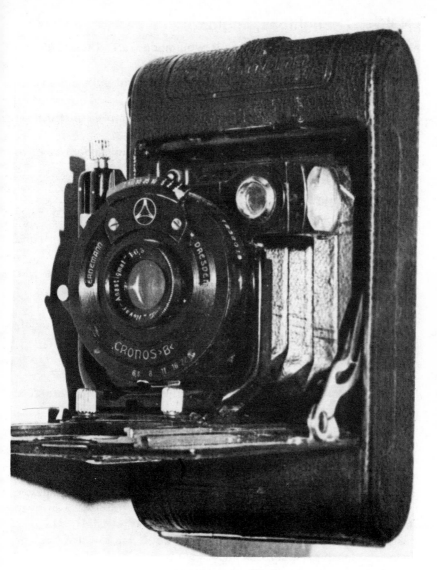

Ernnemann Chronos, $35 - $80

ENSIGN, (Houghtons, England)

REFLEX. Fancy Single-lens reflex is well-made, rare. These 20's big cameras go for $80 to $115.

ENSIGNETTE. Looks like a Vest-pocket Kodak, front pulls out on tiny struts. $20 to $45.

MIDGET ENSIGN. A metal-bodied candid, very simple construction. 127 film. $20 to $40 value.

SELFIX. This 120 folder is ordinary in design, but seldom seen in America. A 50's collectible at $30 value, average.

ERNNEMANN, of Dresden, Germany

CHRONOS. Finely-built folders, for roll film. Leather covered steel-and-aluminum bodies. Values $35 to $80, depending on film size and lenses.

BOB AND BOBETTE. Conventional folders for either cut film or roll. $30 plus value. A rare Bobette 35 with Ernostar lens would sell for over $160. Lesser lenses $50 or so.

STEREO BOB. Rare and seldom seen. Like Stereo Lillipup, highly prized — values, $200 to $275.

HEAG. These are an older line of folding Ernnemanns, circa 1914 to 20's. Many models, mostly for plates and cut-film. $20 to $50.

LILLIPUT. A stamped-metal body camera, vintage 1915 to late 20's. Rare, but not sophisticated. $40 to $60.

UNETTE. Unusual, very small box camera from the 1920's. Leather-covered metal construction. Values, $55 to $100.

Now, there are many models of wood-finish **"TROPICAL"** cameras by Ernnemann, and **FOCAL-PLANE SHUTTER FOLDERS,** these are seldom seen, and are really 'museum stuff'. Prices go from $285 in even shabby condition up to over $1,000! The beautiful **ERMANOX** is in this category — looks like a modern camera. It is a classic of design and workmanship. Again, don't hold your breath 'til you find one, and be prepared to bid against avid collectors who will pay $900 and up for the Ermanox without batting an eyelash! The Smithsonian Institution has one of these cameras — under a sealed glass case!!

EXA I, German SLR, $25 - $40

EXPO
This American firm made a small metal-finish camera looking almost exactly like a large pocket watch. These cameras were marketed from 1907 right into the 'remainder shelves' of the 1930's! A tiny lens is housed in the winding stem, a little view-finder perches next to the 'stem'. Values, $65 to $125. Add to this for factory box and instruction booklet.

FAIRCHILD AERIAL CAMERAS
These giants were cheap after World War II and Korea, today are not easily resaleable. Prices range from $45 to $185, many models, the smaller using roll 70mm film — still available. Avoid these, unless you can practically get them for free.

FAIRCHILD CINEPHONIC 8.
This was the first sound-built-in movie camera for the amateur. Again, rare, but not easily resaleable. Valued at $55 to $115.

Falcon Special
$7 - $15
Photo by Bruno DeGrassi

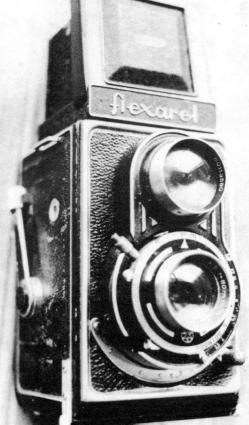

Flexaret TLR
Czechslovakia
$25 - $50

FED
This was a Leica carbon-copy made by the Russians in the 40's and 50's. Cheap construction and poor workmanship. Shutters often malfunction. Nevertheless, somewhat rare. Values, $45 to $115 with case.

FEINWEK . . . see Mec 16

FERRANIA RODINE
Italian 127-film camera, Bakelite body, simple lens and shutter. $20 to $35.

FINETTA 35
A focal-plane shutter model is seldom seen. This 50's German 35mm model goes for $75 to $100. A simpler model called the Finette of stamped steel is more common, sells for $15 to $35.

FLEXARET by Meopta of Czechslovakia
This early 50's twin-lens-reflex was well-made, though not in Rolleiflex category. Featured crank wind on later models, and a lever below the lens for focusing! Prices go from $25 to $50.

FOTH of Berlin, Germany
Many ingenious designs came from this small firm in the 20's and 30's.
FOTHFLEX. An ambitious twin-lens for 120 roll film. Nice focal-plane cloth shutter, not reliable on slow speeds, but . . . I paid $30 for one in '79, and actually got good usable pictures from its lens, using top 1/500 second speed. Rare. Values: $55 to $110. Mint condition, case.
FOTH DERBY. This miniature is often encountered, and also used a focal-plane shutter inside an aluminum body. Wide front lens standard pops out. Top knob winds shutter with one motion, after setting speed by lifting slightly, and setting. Nice beginner rarity, at $35 to $60. A rangefinder model did not sell well, and so is prized, goes from $45 to $95!!

FOTOCHROME
Very unusual design positive instant camera came out of California in the early 60's. Failed in the market, now rare. Value, $30 to $40.

FOTORON
This American oddity from 1961 boasted a bulky plastic body, used 828 film, and electric-drive film advance and flash. The built-in

battery recharges! From over $100 purchase price, the Fotron is now a rarity, but worth only $25 to $50 or so.

FRANKA of Germany

Solida and Rolfix folders are often seen and cheap: Values, $20 to $50.

FUJI of Japan

The Lyra was a normal-design folder, made from 1939 and marketed in the late 40's and 50's. Values range: $20 to $40.

FUTURA of Germany

A rangefinder "35" is the only model I've seen, used a 40mm and 80mm lens, interchangeable. Ambitious design, but cheap construction. Today this very rare brand is a Moderate collectible, and camera would only sell for $55 to $70, with $30 extra for tele lens, more for case, etc. A full kit, with filters and so on MIGHT hit $145 in Mint condition.

GAMA 16

This Italian sub-miniature is respected, offers a 1/1000 sec. shutter. 'Kits' include tiny filters and a special miniature enlarger! Values range: $180 to $240 plus, just for camera.

Gamma "35", $70 - $230

GAMMA
An Italian rangefinder that featured a curved metal focal plane shutter! This 50's unusual camera is prone to shutter problems, but rare. Valued at $70 to $230.

GAUMONT of France
The only attainable model I've seen is the Block Notes, a metal folding 'vest pocket' camera from 1905 or so. Plates or cut-film. Valued at $160 to $200 for its rarity.

Other Gaumonts include stereo models, very seldom seen, priced at $200 to $340 or more!

GEM
Both a Canadian firm and a Rochester, NY company used the Gem name. The American Gems used cut-film, and both, it and the similar Canadian models would be valued at $30 to $65.

G. GENNERT, New York, N.Y.
The **MONTAUK** line was popular for a short time, they are very rare, but not unusual in design. Vintage 1890 to ? A roll-film folder sells for $30 and up, while the wooden-bodied Montauk folder using cut film often has brass trim and red bellows — values, $45 and up.

MONTAUK DETECTIVE. A large box using an internal bellows for focusing. Rare. $140 to $190 value average. A very rare Gennert used the moving lens standard, to give many exposures onto a 5 x 7 inch plate! Natural wood finish, and prized: value, $950 to $1275 plus.

GOERZ of Germany
This old-line firm began life as a maker of lenses only, like Voigtlander, and went on to produce many fine cameras.

GOERZ ANSCHUTZ. Using focal-plane shutters, these models used nickel struts to extend lens standard, like Bellinni and other period "press" cameras. Focusing is by lens in rotating mount instead of by bellows extension. Condition is very important with these, as a 70-year-old shutter would be VERY hard to repair! From a stuck-shutter model at $55, one would go up to $145 for excellent condition, up to $230 for a perfect model, covered in green leather, with case! There is a very rare stereo Anschutz for over $400!

FOLDING SINGLE-LENS. Circa 1913, waist-level viewing, like Graflexes, and rare. $140 and up.

TENAX FOLDER. Fairly common, using roll film, similar to other period folders. $25 to $45 value.

VEST POCKET TENAX. Using 4.5 x 6 plates, this all-metal compact has a leaf shutter, fine lenses. Similar in appearance to the Block Notes. Value, $80 to $135.

PRE-WAR TENAX. This 35mm camera is well-made, not very rare, made by Zeiss . . . see Zeiss of Stuttgart.

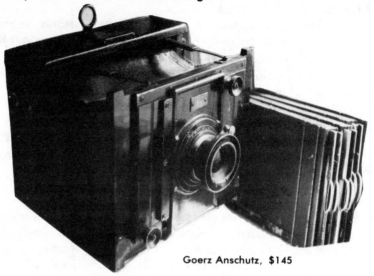

Goerz Anschutz, $145

GOLDECK 16

A fine 16mm miniature, with F 2.8 lens. $115 plus.

GOLTZ AND BREUTTMAN of Germany

MENTOR RELFEXES. These come in both focal-plane models, and those using leaf-shutter-and-lens. A Mentor II is very much like the Anschutz by Goerz. The focal-plane models value from $115 to $210, the Mentor II, around $180. A simpler Klein-Mentor goes for $100 to $130.

MENTORETT. This twin-lens 30's model used a focal-plane shutter is rare. Values, $90 to $190.

MENTOR STEREO. Very rare and prized, at $440 and up.

GRAFLEX AND SPEED GRAPHIC by Folmer & Schweig of N.Y.

This firm made many real American classics — a line of focal-plane cameras in both reflex and press-type design. For over 50 years, the Graflex was the prime journalist's camera, and the hundreds of fine LIFE and other magazine covers were shot by hard-working newspapermen — and women. Eisenstadt, Margaret Bourke-White,

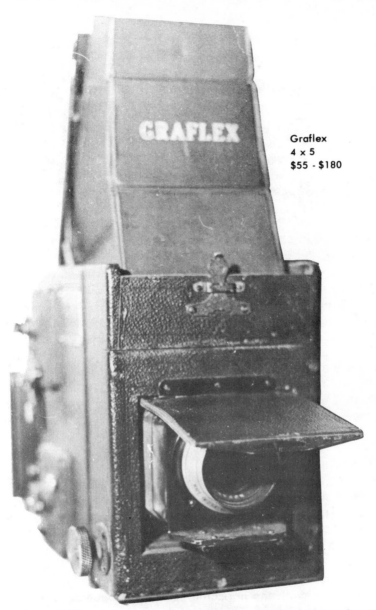

Graflex
4 x 5
$55 - $180

WeeGee, and others. Most photos from the combat zones during World War Two were shot by Graflex-made cameras!! Toward the end of this company's life, the modernized Graflexes shared production with cheaply assembled "35" candid cameras, and inexpensive twin-lens and stereo models. Today, many hundreds of Graphic and Graflex cameras are still used by professional photographers.

Graflex, Graphic 35, $20 - $40

The **GRAFLEX SINGLE-LENS REFLEX** used two controls to set shutter speed, as did the Speed Graphic. One knob determines the spring tension, while a key above it sets the width of the shutter. The Graflex shutter mechanism is really simpler than European versions like Goerz and Theornton-Picard, and can still be repaired by professional repairmen. In my neighborhood, a Clean-Lubricate-and-Adjust will be done for $50 to $75, more for parts needed. The Speed Graphic often used a front lens, with leaf shutter, for flash synching, while the Graflex came with a simple barrel lens. From the first models of about 1910, the Graflex Graphic was prized for its 1/1000 shutter, capable of stopping the fastest sports or combat action. Lenses include the inexpensive Kodak Anastigmat, through Bausch & Lomb, to Zeiss and Cooke.

Film sizes ranged from 3 x 4 inches, through 5 x 7 for most models of the 20's and 30's. From 38 on, a 2 x 3 inch miniature Speed Graphic was offered. Most could be fitted with 620 or 120 roll holders, or film-pack or cut-film holders.

The **NATIONAL GRAFLEX**, using 120 roll film, has a unique design, and a 1/500 shutter. This and the Revolving Back **HOME PORTRAIT GRAFLEX** of more conventional Graflex design are the only models using a 1 500 shutter. Early Nationals have fixed lenses, later II models take a small telephoto lens. The National is just like a small chunky box, with the horizontal-format top opening like a door to reveal the reflex viewer. Shutters are balky on this one, they are harder to repair than other, full size Graflexes. The National is priced from $70 with 'stuck' shutter, to around $160 in excellent condition. The Home Portrait Graflex is valued anywhere from $100 to $230!!

Two models also use roll film . . . the **I-A** and **3-A** models. These look different from other Graflexes, but have the standard 1/1000 shutter. While these are rarer than most Graflexes, they can not be used as

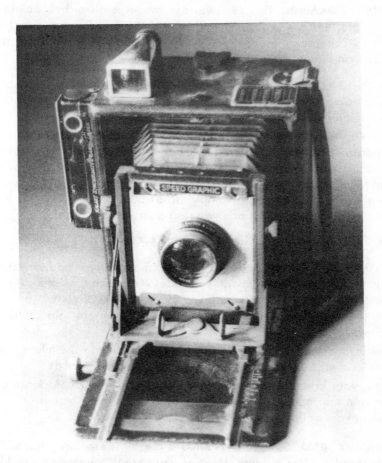

Speed Graphic, ca. 1936, $40 - $100+
see Graflex Corp.

practical cameras as can other models, and so you should not purchase these models with an eye to easily re-selling. I've purchased these models for $60 plus in 1980, but today in excellent condition, either could reach $145 for Mint condition. Don't gamble with these odd-ball Graflexes!

STEREO GRAFLEX. This 1912-vintage model is very rare. Don't confuse with the 50's model tin-body Stereo Graphic! The beautiful original Stereo is of mahogany construction, leather covering, and fetches from $310 to $1,000!!!, more for Mint condition.

COMBAT GRAPHIC. This 1945-vintage model is olive drab painted, has rigid lens extension, no bellows. $280 plus. Combat Graphic, 70mm. This range-finder monster uses roll film, is rarer than the above cut-film model. $280 and up.

GRAPHIC NO. 0. This maverick design used 127 roll film, has only a viewfinder, controls for 1/500 shutter on top of body. Like National, impossible to repair! Value, $160 plus.

Yes, Virginia, there are **CIRKUIT GRAPHIC CAMERAS.** These all wood panoramic cameras used a spring-powered gear train to produce panoram pictures. And again — these are museum stuff; I've been told fewer than 75 of these cameras have survived the 1920's. Prices range from $300 for poor examples to $1,500 for a perfect "no. 10" kit with all attachments, and working gear set and case!

GRAFLEX FINGERPRINT. Unique design, rare. Value, $180 plus.

NATURALISTS GRAPHIC. An extreme extending-front and swiveling viewer mark this design; very few made! Most found in 4 x 5 cut-film version, with Protar lenses made under license by Bausch & Lomb. If you find one in working shape, you have a camera that could be valued from $1,500 to over $2,000!!

There are other very rare Graflexes, including twin-lens and Sky-Scraper, but these are virtually unobtainable, period!

Now, your bread-and-butter Graflexes and Speed Graphics are out there in the thousands, and you will probably come across at least one in your collecting tours.

GRAFLEX AND GRAPHIC, SPRING-BACK. These are made for two-sided cut-film holders. Most of your pre-WWII models are like this. The 3 x 4 inch film models are cheapest, because this size film hasn't been available for over 10 years, except by special order. My 3 x 4 Graflex cost me $49, and it looks nice on a shelf, but it's not usable! In Mint shape, a 3 x 4 Graflex MIGHT go up to $100! A sandwich-type roll holder was made for 620 film, but is rare itself, at $35 plus. The 4 x 5 film model is more prized, sell for $55 to $180.

The **GRAFLEX** and **MINIATURE SPEED GRAPHIC** were made in 2 x 3 inch film size, and this available film makes these models usable. The rarer 2 x 3 Graphic would sell for $55 to $100, while a Speed Graphic would make you into a photo-journalist, with case and flash and roll-holder, for "only" $85 to $180!

SUPER D GRAFLEX. This 1950's vintage Graflex had flash sync on the focal-plane shutter, and removable back. Many of these fine cameras are in day-to-day use. The very versatile 4 x 5 model brings prices up to $340 in Fine condition with case. The sharp Ektar lens is a collectible in itself!

The **POST-WW II GRAPHICS** and **GRAFLEXES** had a removable back, for factory-made roll backs. With a coated lens, these in 3 x 4 and 4 x 5 and up to 5 x 7 sizes are more valued than pre-war models. The 50's vintage better Pacemaker Speed Graphics have tilting front lens standard for architectural shots, and table-top photography. Values anywhere from $85 to $180.

CENTURY CROWN GRAPHIC. This plastic bodied Graphic had no focal-plane shutter, but many lenses and shutters could be fitted. The 4 x 5 model with roll back and quality lens like Zeiss is a very usable model, though not the same workmanship as the 'old' Graphics. Values $95 to $185.

Accessories include the RH-8 and RH-10 roll holders, and fitted cases holding filters and flashes. Lenses like the Optar F 3.7 and Ektars are prized above lesser brands, as are Goerz, Zeiss Protar, etc.

Generally, the 5 x 7 Graflex is rare than other sizes, and are collectible because of rarity. BUT — don't 'go into' Graflexes unless you have a lot of storage room. They are beautiful classics, but they are big and heavy, and generally do not 'move' especially well!

Modern Graphics:

STEREO GRAPHIC. Made in the 50's — 1/200 shutters, thin metal construction. Valued at $65 to $95.

GRAPHIC 35. Uses an odd push-button focusing, not a good seller. A 'Jet' model made overseas used a CO_2 cartridge to advance film! Values go from $20 to $40.

GRAPHIC 22 TWIN-LENS. This TLR is almost identical to the DeJur and Ciroflex models. A nice 'beginners collectible'. Prices: $10 to $30.

GUNDLACH-MANHATTAN, Rochester, New York

See also Manhattan. The most-encountered model is the **KORONA FOLDER**, many featuring red bellows and brass metal-work. Sizes from 3 x 4 to 5 x 7, larger sizes are rarer. A **STEREO KORONA** is very rare. Standard models bring $30 to $70, while the stereo can hit $115 to $100. Manhattan made **WIZARD** and **BO-PEEP** folders, nice-looking but ordinary in design.

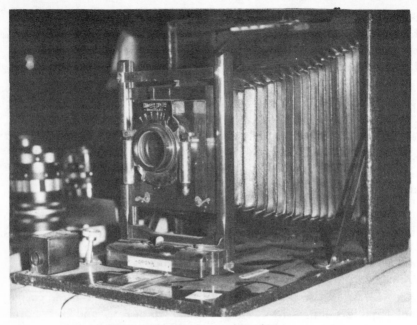

Korona III View camera, $30 - $70
Photo by Bruno DeGrassi

A **NIGHT HAWK DETECTIVE** was made in leather-cover and plain-wood finish, can bring $180 to $340. Manhattan Optical, like Rochester and Century and Seneca all eventually succumbed to the aggressive marketing of George Eastman and the "Yellow Box Gang" of Eastman Kodak.

GUTHE & THORSCHE of Germany

KAWEE PATENT ETUI. A very compact folder, often encountered, from the 20's and 30's. Values, $20 to $50.

PILOT 6. A box-like camera for 120 film. Look for Tessar lens of Super model. Prices range: $30 to $70.

PILOT TWIN-LENS. Unusual design, using extended front and 127 film, from the 30's. Rare. Values, $205 to $340.

PRAKTIFLEX. Cheaply made 50's Single-lens "35". Value, $40 plus.

PRAKTINA II. Mediocre single lens "35", accepted motor drive! Priced at $95 to $130, Fine condition, working!

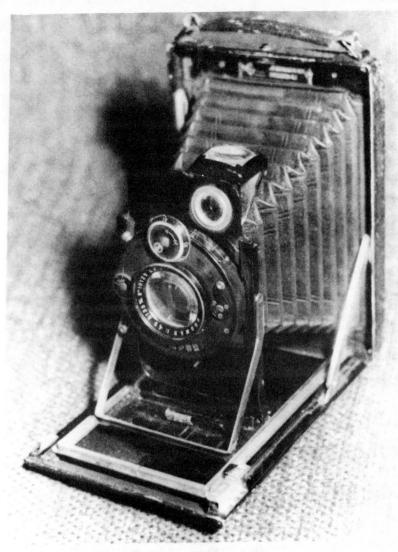

"K & W" German Folder, 1925 - 1935, Value $40+, Etui model.

HARNAU of France

This turn-of-the-century maker is best known for a stereo called the Marsouin. Of all metal construction, seldom seen and rare. Values, $340 to $465.

HASSELBLAD of Sweden

This modern name in expensive cameras made two models that are collectible because of their use of a focal-plane shutter. The design did not work very well compared to modern Hassys with their leaf shutters.

MODEL 1600F — this '48 to '54 or so model is relatively rare, valued at around $315 to $420, more for extra lenses or if the shutter has been recently over-hauled (a costly business!!).

MODEL 1000F — This better-selling Hassy is often seen at big camera stores or large collector meets. Prices range from scruffy examples at $295 up to mint models for $650 plus including an extra lens or two!

HERBERT GEORGE

This little American firm made plastic snap-shooters named after Donald Duck and Roy Rogers! Prices, $12 to $20.

HESS, Ives of Philadelphia

A Hicro color camera was simple in design, a leather-covered cube with simple lens-shutter, square at the front, for 3 x 4 inch plates. Values, $90 and up.

1920's Heidoscop Stereo for plates, $250 - $450

HOFFERT of Germany . . . see Eho

HONOR
This Japanese postwar "35" was a Leica copy, generally of good workmanship. Most have flash sync, later models sport a self-timer. From 1954 on, valued at $80 to $120.

HORSMAN & CO., New York
I've only seen the Eclipse from this 1900 to ? company. These nicely-finished plate cameras came mostly in 3 x 4 and 4 x 5 inch exposures, often have red bellows, brass trim, etc. I once saw a valuable model with German Compound shutter and Zeiss lens, but most use Bausch & Lomb, other American equipment. Values $180 to $265.

HOUGHTON-SANDERSON — see Sanderson

HUNTER OF London, England
GILBERT. This 40's vintage box is simple but rare, many have snakeskin-covering over a tin body! Values, $35 to $60.

PURMA. An ordinary and Special model both used plastic bodies, simple lens, and a gravity shutter, that gave you three speeds, by holding the camera right-side, up left or up right! The Special had a flash sync. For 127 roll film, this 50's oddity fetches $35 to $60, with case.

HUTTIG of Dresden, Germany
ATOM. A small all-metal rare model, for 4.5 x 6 cm. Prices range: $140 to $230.

HELIOS. Uses struts for pull-out, no folding bed. Leather bellows, nice workmanship, moderately rare. This 1909 to ? folder goes for $145 to $170 and up.

IDEAL AND IDEAL STEREO. Most use plates and cut-film, various sizes and lenses. Values, $30 to $65.
Ideal Stereos are rarer, with prices ranging from $120 to near $225 in excellent working shape.

LLOYD. This is a fairly common Huttig, similar to Kodak Recomar and Maximar and Avus and a host of other 20's vintage folders. Many models and sizes, using cut film and wide roll film. Prices range: $30 to $65.

MAGAZINE MODELS. These early 20th century models are mostly big boxes, similar to our own Cyclone Magazines. Seldom seen, simple lens and shutters: $80 to $145 value.

Other Huttig models include Stereos besides the Ideal. As with all stereos, look for value points: Red bellows, Zeiss or Goerz lenses, a variety of shutter speeds, and focusing capability! Values I've encountered: $125 to over $200.

ICA of Dresden, Germany

Bought out by Zeiss in 1926, many models subsequently sold under Zeiss-Ikon logo.

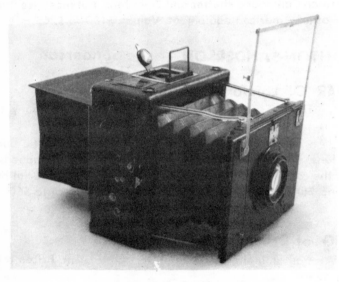

Ica Reporter, $125+

ICA ARTIST REFLEX. Using focal-plane shutter to 1 1000 second. From pre-World War I; leather-covered wooden body. Value $145 or so.

ICA ATOM. Very compact folder from 1912, and rare. $145 plus. Corrida, for cut-film or plates. Value, around $25 to $35.

DELTA. Plates or film-packs, single and double extension bellows models. (Don't confuse with Krugener cameras of Frankfurt). Prices vary: $20 to $45.

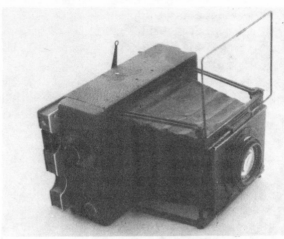

Ica Minmun Palmos $160

IDEAL. Again, various sizes and lens-shutters. A popular model for both Ica and later Zeiss. Valued at $30 to $50.

HALLOH. Early, cut-film, later roll-film. As with other Icas, Compur shutter preferred. Values, $20 to $40.

MAXIMAR. Another good seller, often seen. Valued at $35 plus.

NELSON. Made with single and double bellows. Value, $40 plus.

NIXE. Some models used roll film, some plate models had triple-extending bellows and spirit levels. Prices: $30 to $60.

SIRENE. Various sizes of cut-film. Valued at $30 plus.

Other similar models: Niklas, Trix, Trona, and Volta . . . most would sell for $20 to $60, depending on condition, extending bellows and lens fitted.

ICARETTE. These were all roll-film models, often seen and usually affordable, at $20 to $40.

VICTRIX. A small plate camera, for 6 x 4.5 cm exposures. Rarer than most above models, value $60 plus.

FOLDING REFLEX. Another single-lens type, with focal-plate shutter, excellent workmanship and rarer than many competing brands. Values, $125 to $230.

PALMOS. A big, well-made folder using focal-plane shutter. I've seen rare examples with brown and tan bellows. An impressive Ica, but rare. Valued at $160 plus. A stereo version is even rarer, of course: $200 plus.

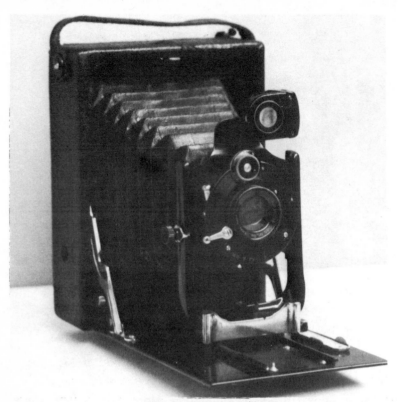

Ica "Serenne" Folder $30+
Photo by Bruno DeGrassi

POLYSKOP. A well-known name among stereo buffs, made in 2 sizes, both for plates or cut-film. This all-metal model dates from the early 20's, sells for $120 to $190.

STEREO IDEAL AND STEREOLETTE. Both are folding bed-and-bellows types. Stereolette is smaller, more affordable at around $120 and up, while the slightly bigger Ideal can hit $210.

TROPICA. Beautiful and expensive — teak or black mahogany, brass or nickel fittings, and so on, and tan bellows is a nice touch. Took many lenses, from Ica Anastigmat (so-so), to Zeiss and Goerz Dogmar (much better). Like all Tropicals, look for peeling lacquer or damaged bodies — could be tough to restore, have you asked your local lumberyard for a 2' x 3' piece of seasoned teak lately? Values, from scruffy shape, $240, to Mint, over $650!!

UNIVERSAL JUWEL. Rare, I've never seen one. Believe used bigger film — 9 x 12 or 10 x 15 cm, and supposed to have rotating back, and a falling bed, for using wide-angle lenses! Value guesstimate: $65 to $100.

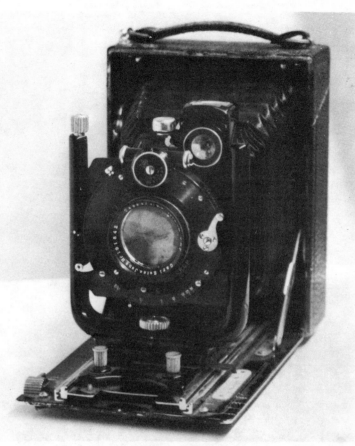

Ica "Nelson" Folder $40+
Photo by Bruno DeGrassi

IHAGEE of Dresden, Germany

I'll start off with the Exakta models — shaped like a trapezoid, heavy, clunky and built to last a lifetime. The Exakta A and B models use 127 film, and were made from 1936 to 1945, while a rare model, the Square or 6 x 6 model, used 120-film — look for bottom film-advance lever and 80mm lens size on this one.

The 127 "A", "B", and "C" and Junior have various lenses offered, and all but the Junior have interchanging lenses. Features include self-timer, and the "A" and early "B's" have a film-advance knob, instead of lever as on later Exaktas. All have waist-level viewing hoods, and the A comes only in black finish.

The "A", "B", "C" and **JUNIOR** all sell for $115 (sluggish shutter or dents on body) to $250 in nice shape; the **120-film model** can go as **high as $310.**

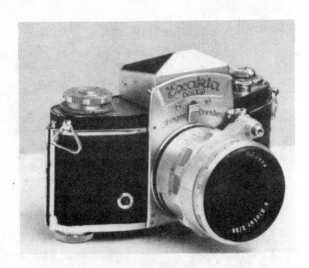

Exakta VX - IIA
Photo by Bruno DeGrassi
$55 - $85

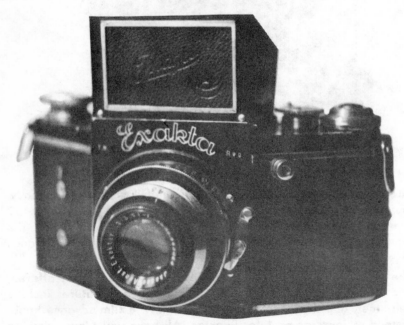

Exakta Junior, $115 +
see Ihagee or Germany

The Exakta you'll probably encounter will be the more common 35mm film size:

EXACTA I. Early models have the name spelled Exacta. Shutter is locked when the viewer is folded and closed. Serial numbers below 600,000. This and the "II" have one set of flash contacts, on right-hand side, and non-removable reflex viewer. Valued at $45 to $85.

EXAKTA II may come with the sharp F 2.0 Biotar, instead of the lessor F 2.8 Tessar. Avoid the Westar and Isco and Steinheil lenses. Prices range $45 to $85.

EXAKTA V. Serial numbers to 695,000. Reflex-viewing hood removes, can be replaced with eye-level. Two sets of flash contacts on this one. Value, $65 to $95.

EXAKTA VX. This more usable model has an improved shutter and slow-speed mechanism, and a film-speed indicator. F 2.0 Xenon and Biotar are 'better' lenses. Made from $52 to '54. Values: $55 to $70 to $100 with case.

EXAKTA AUTOMATIC AND VX-IIA AND VX-IIB. These are improved models, with better and quieter gear-trains. Values: $55 to $85 to $125 in perfect condition.

You may find more modern Exaktas, such as the **EXAKTA 500**, and the little **EXA I AND II.** These are not as mechanically finished as the earlier models, and not as respected among collectors. The 500 is really a snap-shooter, in my opinion, and for $50 plus, good for Christmas gift to the teenager in your family. I've paid $25 to $40 for Exas with Westanar lenses . . . they're a good, affordable beginner's collectible, and that's all.

IHAGEE DUPLEX. This 20's model camera was a good press camera in its day, with focal-plane shutter, and usually a leaf-shutter-and-lens up front. They're rare, but the focal shutter usually has problems. Value: $50 to $80 to $115 in perfect working order with case.

IHAGEE PARVOLA. Looks like a Kodak Pupille, takes 127 film. Nice brass helical focusing barrel; a lever beside the lens mount locks the shutter 'til you push it out. This 1929 to ? precision camera can be bought for $35 to $85.

IHAGEE ULTRIX. An ordinary-looking folder, some models have an advanced helical focusing mount. 30's vintage. I've seen these for $20 to $50.

IHAGEE PAFF. A box camera with reflex-viewing, that takes 120 film. Simple lens and shutter, but rare. $45 and up.

Ihagee Duplex ca. 1926, $50 - $115

KLAPP REFLEX. This is a single-lens-reflex model, competing with the Graflex, Thornton-Picard, etc. Unusual appearance, but very well made, and rare. 1 1000 shutter, focal-plane type, (and usually broken!). $85 (stuck shutter) to $180 in "good" condition, to a perfect $240 with case!

Ihagee also made a **STEREO CAMERA, PRE-WORLD WAR II,** which I have never seen and is extremely rare, and many ordinary folding camers (look like Recomar and Avus and Maximars) that are valued at $25 to $50.

P. S.: The modern Exakta is made-in-Japan creation, with no collectible value.

ILFORD ADVOCATE, England

A mediocre "35" from the 50's. 1 200th leaf shutter. Value around $35.

ILFORD WITNESS. Top of the Ilford line, this all-metal "35" boasts a 1/ 1000 sec. focal-plane shutter. Vintage 1956, value ranges: $230 to $445.

ISO of Italy

A Duplex and Super Duplex are stereos from 1952, using 120 roll film. Unusual design makes for rarity. Duplex, value $140 or so, while Super Model, $180.

JEM BOX CAMERA, Newark, N.J.

This is an all-metal box. One-element lens makes it a marginal picture-taker; a good beginners collectible. Valued at $3 to $10.

JENNERT MONOBLOC

A metal-body stereo product from the 20's in France, for glass plates. Moderately rare, so would go for $135 to $230.

JOUX of Paris, France

The French were mad about the stereo, as you might guess. This turn-of-the-century stereo was made in several models, is rarer than Richard and other big sellers. Value, $145 to $210.

The word Jumelle means 'Two of', or 'Twin', and is part of the names of many French stereo cameras. Usually these have rigid bodies, with a front, rigid standard carrying the lenses for focusing, (this by number, since the early stereos have no rangefinders).

JUWEL — see Zeiss and Ica

JUBILEE — see Bolsey

JUNIOR REFLEX — made by Reflex Camera Co. of Newart

KALART, New York

A press camera was made by this more famous producer of add-on rangefinders. They should have stuck to finders. Not in the same league with Speed Graphics, but moderately rare, so valued at $115 to $160 with decent lens and shutter.

KALIMAR of Japan

MODEL A 35mm CANDID was cheap, so-so in workmanship. Prices range $10 to $30.

KALI-FLEX. Thin-metal-body twin-lens reflex, with 1/100 leaf shutter, for 120 film. $15 to $30.

KALIMAR 660. Using 120 also, this plastic and sheet steel compact single lens is usally found in barely working condition. It is no prize, despite focal-plane shutter and screw-mount interchanging lenses. Values vary, $30 for sticky shutter, fair shape, up to maybe $75 in near Mint and working condition.

KALLOFLEX, from Kowa of Japan

Twin-lens model much like Rolleis, not as respected as Koniflex. Valued at $70 to $135.

KEMPER KOMBI

From 1895 comes this tiny box of sheet steel that doubled as a viewer. Sold very well, but so many have been gobbled up by collectors that they're becoming rare. This all-American miniature sells for $85 to over $160.

Keystone Movie Camera 16 mm
$10 - $30

KEYSTONE STREET CAMERA

An American positive-picture camera much like the Mandelette, looking like a satchel or box with cheap lens and shutter stuck on front. Prices, $90 to around $145.

KIEV

Fair quality copy of Contax rangefinder, from Russia, late 50's to 60's. Valued at $70 and up.

KOCHMANN of Dresden, Germany

Two 4.5 x 6 cm models were made, one a fairly conventional folder, the other extending lens standard on struts. First model would sell for $30 to $55, while the rarer strut Korelle shows better workmanship, is valued at $75 to $140.

KORELLE REFLEX. This 30's vintage single-lens reflex is a minor classic, with a cloth focal-plane shutter, and screw-mount lenses, from a poor quality Victar up to excellent F 2.8 Tessar. After World War II, these came out again, marked by Burke and James. Model I is

Korelle 127 Folder, $40 +

common, while Model II has some extra slow speeds and a self-timer (this usually doesn't work unless the camera's been overhauled). Because of some copyright hassles, some Korelles were sold under the **MASTER REFLEX** label. A rare copy was made by the English during World War II as the Agiflex.

Most Reflexes will go from $55 with Victar or Radionar, up to $125 with Tessar, working shutter and case.

EASTMAN KODAK

This is the big one . . . 3 or 4 out of every 5 vintage and collectible cameras you'll probably encounter will be Kodaks! From early models of 1888, mass production into the 1960's poured over 35 million Kodaks onto the camera market!

Identify early and many later Kodaks by appearance — they don't usually have a number or model on outside, though these are sometimes found inside the hinge-out or removable back. I only consider 50 Kodaks to be collectible at all, and I'll cover what I consider the main ones here. For Kodak Nagels — see Nagel.

VERY EARLY BOXES. The rare **STRING-PULLS** (1889 or so) use strings on top body to set shutter. Large wooden bodies — rarer wood-finish — most have leather covering. Model names include No. 2, No. 4, "Ordinary A" etc., etc. Bodies are rectangular — longer than wide. Some models have brass key to advance film. The front panels or doors open via two screws to show lens and simple shutter behind. Patent dates (inside body) 1889 to 1895 or so. Prices encountered: raggedy-flea market $100, to $150 to $200 and up! A perfect string pull with early patent date inside — $380 plus! The **"ORIGINAL KODAK**, with above mentioned two screws on front — $2,000 and up whether Very Fine or Mint. An 1890's line of 3 & 4 models, NO string, plus focusing wheel atop body — value $285 plus. Plain wood finish body Kodaks, 1891, rare — $540 to $900! "C" Daylight Box of 1891, offered focusing by lever atop body, 2 speed shutter, value — $200 - $390.

BULLS-EYE, BULLET BOXES. Most common Bulls-eye is No. 2 using 3 inch wide film. Top and inside structure lift straight up and out! No. 2 — value, $25 plus, No. 4, $30 plus, No. 3 loads from right side, like No. 4, $35 plus. Bullets are rarer, but can vary widely: values I've seen: $20 to $30 to $60. And there is a folding Bulls-eye — value $30 and up. There is also a Eureka box at a little more, $100 plus, and a very similar Flexo.

The Autographic cameras all have a small window on the back, and a stylus to engrave date and place of the picture. The "Special"

models usually have a Bausch & Lomb lens, and often an Optimo shutter, better than the usual Kodamatic or Ball Bearing types. The Specials come in 1, 2 and 3 models, with a few equipped with the very good Kodak Anastigmat Special lens, Bausch & Lomb, or the Zeiss Anastigmat Kodak lens.

With the better lenses, value can go from $30 to $45, while the regular lens models sell for from $15 to $25, depending on condition. Film sizes include the now dead 118, 130 and 122 large roll sizes.

The Rapid Rectilinear lens is found on most of these, and was an "ordinary" design. Most of the Autographics from 1914 into the early 20's used this lens, and the Ball Bearing shutter. I pick these up for from $9 to $15. Remember that in the period before and after World War One, over two million of these metal-bodied folders were made — they are not rare!

The high point of Autographics would be similar to one I own: A Zeiss lens, and Bausch & Lomb compound shutter (look for the slow speeds down to 1 full second). With case and a "close up lens" in mint condition, this model would retail for $40 to $55 — I paid $15 for it at an outdoor flea market one Wintery day in 1981!

And of course, all Autographics with the coupled rangefinder were Special, and are worth $25 even in Fair condition, up to $60 with case, in Mint shape.

THE HAWKEYE is a venerable name, going back to 1900, when a box camera came out under that name.

The word Cartridge in Kodakspeak means roll film, while a film-pack is a form of storing individual sheets of film, where they can be exposed one at a time.

Box Hawkeyes all go for around $8 to $10, even the earliest models, because so many were made. All the Hawkeyes, both box and folding, expose 2¼ up to 3½ inch wide film . . . I've never heard of a "big" Hawkeye, such as one finds as the Nos. 4 and 5 bigger brother Kodaks. The Hawkeye and the Brownie were in their day the Volkswagen Beetle of cameras.

What do you look for? Well, the no. 3 Hawkeye folder from 1915 on often has a red bellows, and is usually horizontal format. Finished wood drop-down bed and a nice nickel-finish air shutter help value also. These models can go for from $15 to $35 depending on condition, extras like case and instruction booklet, etc.

Some no. 1 and 1A Hawkeye folders also have red bellows, and a few have Kodak "Tessar" lenses, made under license, and better

shutters, with a wide range of speeds, down to ½ and 1 second. These are valued at around $20.

Many film-pack Hawkeyes have square bodies, in painted bare metal — no leather or oilcloth covering! A fellow collector told me this was because during the Great War, leather was in demand for the US Army! Anyway, these models are still pretty common, and should not go for more than $15 or so.

The Hawkeye Special and Vest Pocket Hawk are two more variants, and go for $8 to $20, depending on condition.

The Hawks I like are the colored models — Rainbow, both in box types and folding. All the colored Hawks have simple lenses and shutters, but are rarer than the black models. But they are still NOT really prizes, because over 200,000 were made over 15 years of production!

Red, green, blue and tan are the colors, and none are found in greater quantity than another. The boxes are valued at $8 (Fair shape), up to $15 or a little more for Excellent shape.

The folding Rainbows go for a little more: $10, $15 and $22 with case. Of course, some like to ballyhoo these, and you may see price tags of $30 or even more — don't be fooled; you would never be able to re-sell these cameras for near this price!

And don't get Rainbows confused with Boy and Girl Scout models — these are rarer.

And, yes, there is even a Brownie Hawkeye — a plastic, Post-War two model for 620 film, that sells for circa $5.

BROWNIE BOXES and FOLDERS. Brownie name used on boxes and folding. Nice folders can go for $25 to $30 with case. Brownie boxes are very common — from a ca. 1909 model at $18, I've seen these little "everyman" cameras sold for as little as $1! Look for last patent date inside body — good condition can add a few dollars value. The original Brownie is very rare, but second, third and succeeding model Brownie boxes sold widely, valued $20 to $45. These circa 1900 ones also have a brass or nickel film-advance key on TOP of body, and often a tiny add-on viewfinder.

The First Brownie was a card-board box, that appeared in 1900 in two versions. The first model had a back that just slid off, like a lid of a hat- or shoebox. And this original Brownie had a small detachable square viewfinder that fitted to the front top of the camera. Both this and the second, more common version have metal keys atop the body to advance the film. This second version also has a metal strip that slides off twin studs, to loosen the back, that is now a single fold-off panel.

I've seen Original Brownies go for $40 to $80, while the more common later model is valued at around $15 to $25.

Most Brownie boxes are made of sheet steel or aluminum, and about 2 million or more were made from ca. 1919 into the early 1930's. Colored Brownie boxes in red, blue and green can go as high as $30, but most everyday values are half that.

Almost all the folding Brownies I've seen are horizontal in format, with the very early versions (1904) having red bellows, and with film advance key on right top of body. Most folding Brownies are not rare, so condition and eye appeal are important. Values range from $15 to $40, — the latter price should include a case or at least an Instruction booklet.

The last two categories I'll include are the **POCKET KODAKS**, made from about 1922 to 1931, and the often-encountered "616" and "620" models, simply named for their respective film sizes.

The Pocket Kodak series are all folders and shouldn't be confused with the rare 1895 box camera, a wooden bodied, almost miniature box with detachable top that is worth around $80.

There were regular Pockets and Junior versions. The No. 1 and 1A Series II have a "self-erecting front", with three pieces of side-metal holding the lens-board rigid. Most other Pockets have the lens-board sliding back and forth on metal tracks for focusing, like most folding cameras of the day. Value, about $15 - $35.

Numbers in the Pocket range are 1, 2 and 3, and 4 film sizes were offered, only one (620) still buyable today. Better quality models will feature the sharp Kodak Anastigmat F 4.5 lens with Kodamatic shutter, offering 7 shutter speeds, plus B and T.

From a low value placed on most Pocket Juniors of '29 to '32 of around $10 to $20 (blue, brown and green models add $5), through most models with their plain lens and Ball Bearing shutters ($12 to $20), one can find the better Pocket models, with Kodamatic or Diomatic shutters, and F 4.5 lens. With case and instruction booklet, these would go for $15 to $30, tops.

Remember, some Pockets had the Autographic feature, and weren't CALLED Autos — no real difference in value.

The **620** and **616** models were made during the 1930's, and all had metal bodies, and most had "self-erecting" fronts like the Pocket Juniors.

Some collectors like these, because both film sizes featured an 8-sided lens-plate (octogon) and a semi-art-deco styling, that makes them stand out.

But for intrinsic quality, it is the addition of a Compur, made-in-Germany shutter that is the best feature of these models — but rarer than the Octogon models above.

Some values for these models: Kodak 616 with F 6.3 lens, Octogon lensplate, Very Good condition, $15 to $20 . . . Kodak 620, F 4.5 lens, with regular sliding lens-board, Excellent condition with Diodak shutter and case, $30 . . . Kodak 616 Improved with F 4.5 lens and COMPUR shutter and case, Excellent shape, about $35 to $40.

There are also Junior 616 and 620 models, with little or no Art Deco styling, that were made right up to 1939, with styling changes here and there; these can have better Diomatic shutters, but most use simpler models: Values range from $8 for Fair condition, up to $25 for Mint shape with case. AND there is a similar line of Senior 616 and 620s, with like values. An exception: a 1939 Special 620, with F 4.5 lens, Compur shutter — paid $45 for mine, and it takes pictures comparable to my $100 Rolleiflex!!

FOLDING POCKET KODAK-1. This is a common but well-liked Kodak collectible, noted for a self-erecting pop-out front. The 1899 original has a leather covered 'box' front and red bellows. Look for brass struts ($90 plus). Most have nickel plate, value $45 plus.

MODELS "1" and **"1-A"** have vertical format, metal spider-legs and a "domed" fold-down door. The **F.P.K.'s Nos. "2", "3", "4"** are more conventional, all go for $20 to $45. The big **No. "4"** uses 4xs and might be valued at $50 in perfect condition. AND, yes, there is a **"SPECIAL" MODEL.** I owned one with Zeiss-Kodak lens, and it took excellent pictures, 'til I sold my $10 beauty for $20 in '79. Value today up to $60!

UNUSUAL & EARLY:

SPEED KODAK. This rare Kodak has a focal-plane shutter in its vertical body, $250 plus. Check shutter condition — important!
CARTRIDGE "4" and "5", 1897, wide roll models, value — $90 plus.
SCREEN-FOCUS. The No. "4" screen-focus is rare but not terribly expensive. The whole back folds up and out — ground glass remains for focusing! A nice "sleeper" collectible. Vintage 1904 to ? I've paid $40 to $75 for these — top price, $295 plus.
STEREO & PANORAM EARLY MODELS. Named **No's. "1"** and **"2" STEREO** — latter a box-type! No. "1" valued from $125 and up, while rarer No. "2's" go for $200 plus. **PANORAMIC KODAKS** made from 1901 into 1920's! Early patent dates: $110 to $230, while later dates would go for $85 to $200. Models include "1", "2" and "4" — anyone see "3"?

Kodak Stereo, ca. 1901 - 1905, $200 - $300
Courtesy, John Groomes

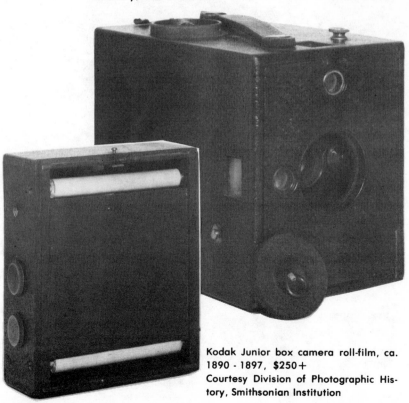

Kodak Junior box camera roll-film, ca.
1890 - 1897, $250+
Courtesy Division of Photographic History, Smithsonian Institution

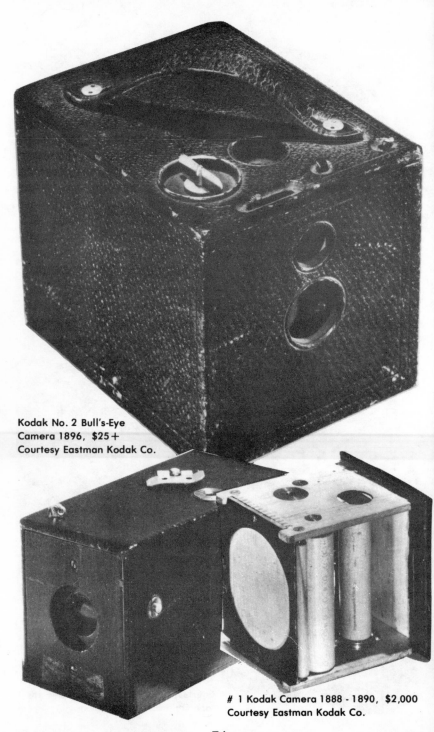

Kodak No. 2 Bull's-Eye
Camera 1896, $25+
Courtesy Eastman Kodak Co.

1 Kodak Camera 1888 - 1890, $2,000
Courtesy Eastman Kodak Co.

Kodak No. 1 Brownie Camera 1900, $25 - $50
Courtesy Eastman Kodak Co.

VANITYS, OTHER VERY UNUSUAL: These are ensembles or kits including simple camera, lipstick holders, mirrors, etc. called **PETITE, VANITY** and **COQUETTE.** Prices encountered, $80 to $175 to $250 plus.

"GIFT" Kodak kits are colored - art deco decorated on camera and gift box — values, $180 to $290 plus. Very rare.

KODAK PREMOS, PREMOETTE. The Premo name was bought by Kodak along with everything else belonging to Rochester Optical! Some used plates, others were roll-film types. See illustration for unusual construction of some of these. A good beginner's collectible. **No. 1** and **JUNIOR** — value $15 plus to $30. **No. 1A** special **PREMOETTE** (German shutter) $20 plus to $35. **FOLDING PREMOS, SENIOR** valued at $40 - strange **6 x 8 size** - $90. Many Premos are 4 x 5 - look for red bellows - go for $25 to $45. **PREMO PLATE FOLDERS,**

1920's - $25 plus. Little more for 5 x 7 - to $50. **ROLL-FILM PREMOS,** $9 to $15, **PREMO JUNIOR BOX** - $10 plus.

KODAK BOY SCOUT, GIRL SCOUT FOLDERS. Introduced about 1930, these Scout models were really just vest-pocket folders with a name-plate beneath the simple lens and shutter. There is even a **CAMP-FIRE GIRL'S** model! All are worth $30 to $50 mint.

KODAK PONYS. In 828 and 35mm sizes, the Pony is very common. This 50's vintage plastic and sheet metal candid valued at $12 plus.

KODAK QUICK-FOCUS 3B. A strangely made deluxe box, focusing by setting a distance, then releasing spring-loaded front — which pops out to set distance! Made 3 x 5 pictures on "No. 125" film. Rear hinges 'up' to load rolls. Made 1906 to ? , the Quick-Focus is appreciating fast, as one of the "interesting" Kodaks. Values, $70 to $110.

KODAK RECOMAR 18 & 33. These German made folders have excellent workmanship, but are common enough to be "in reach". Look for Goerz or Tessar lens, (add $5) — otherwise $45 plus, little more if rangefinder "added on". Nagel Recomars, see Nagel of Germany.

KODAK TWIN-LENS-REFLEX. In "I" and "II" (flash sync) models. The cameras have good lenses, but are mediocre otherwise — not in same class as Roueiflex or even Ansco TLR. $20 to $45, either, but "II" is preferred. Made 1947 to '54.

KODAK PUPILLE 127. This rare, compact made-in-Germany camera had unusual focusing mechanism, fine finish. 1932 vintage, with respected Xenon lens, leaf shutter. $100 to $250. Aluminum body with leather covering.

KODAK DUO-620 and **VOLLENDA 620.** Folding 30's vintage. Duo made with rangefinder also — value $35 plus, Vollenda 620, $40 plus, medium rarity. **VOLLENDA WITH ELMAR LENS,** super rare, $200 plus, fine shape.

KODAK BANTAMS. The simple F 8.0 lens Bantam is common, goes for $10. A F 5.6 lens model is better, but the all-metal F 4.5 lens "Flash Bantam" is often encountered, and has a neat late-1930's to 40's design. I have two F 4.5 Bantams — paid $15 for each of them — top value would go to $25, with case.

But the sought-after Bantam is the **SPECIAL** (1940 to 1948). This art-deco styled camera was designed by a famous industrial designer, and was commended by the Museum of Modern Art! A tough plastic-and-metal body covers the lens and shutter completely when folded. This rangefinder classic uses 828 film. I have seen both

Ektar and Xenon lenses on these. The supermatic flash shutter adds value, compared to the German compur.

Values vary: A 1941 vintage model, good condition, with compur shutter — $110 plus, while a post-WW II in excellent condition with a supermatic shutter, plus case — $180 plus!

Kodak No. 3 Folder, ca. 1918
$15+

Eastman Kodak, No. 4, ca. 1907 - 1914, $20+
Courtesy, John Groomes

Kodak Duo
Six - 20, $30 - $60
Courtesy Eastman Kodak Co.

Kodak Vallenda
$40+
Courtesy Eastman Kodak Co.

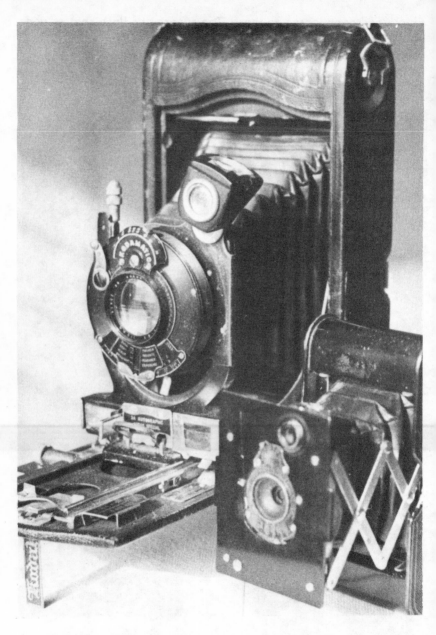

Left: Kodak No. 3 with rangefinder, 1920's, $30 - $55
Right: Vest Pocket Kodak, 1920's, $15+

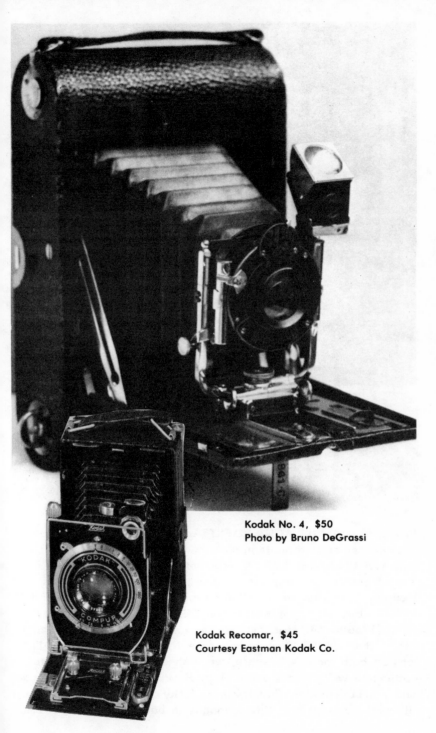

Kodak No. 4, $50
Photo by Bruno DeGrassi

Kodak Recomar, $45
Courtesy Eastman Kodak Co.

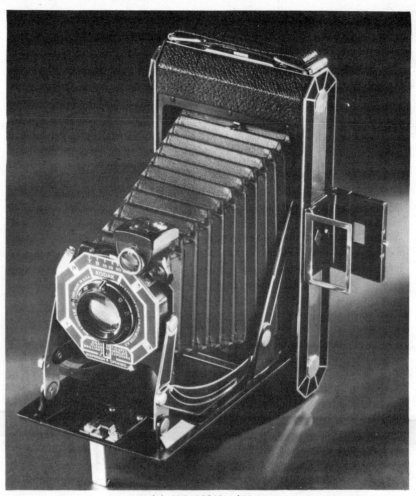

Kodak 616, 1920's, $15+

MEDALIST AND CHEVRON AND EKTRA. The Medalist uses 620 and is encountered more often than the others. The bulky Medalist "I" was begun in 1940; World War II interrupted production. A black high-impact plastic focusing barrel identifies this model. Shutter and focusing rings often malfunction on this model. Appearance similar to "II" — but this one has aluminum alloy focusing barrel, and flash sync! (1946 to '48). Medalist "I's" sell for $80 plus, while the better "II" is valued up to $200 or so with case, in excellent condition! Ektar lens on both models is sharp, while the 1/400 second shutter is nothing to write home about. Typical squinty-but-accurate range-finder on both models. Count yourself lucky if you can find a Medalist "II" with close-up lens, filters, magazine back, case, etc. — value

could go as high as $285! Look for model ID on top of machined body, or tell-tale sync connection on the valued "II".

P.S. '620' film is still available!

KODAK CHEVRON. This 620-film camera is rarer than the Medalist. It offered a F 2.0 Wollensack or F 3.5 Ektar lens in an undependable Y800 second leaf shutter. The Chevron was a rangefinder, and produced from 1953 to 1955. It was more of a "Large Signet 35" than a small Medalist — no magazine back or other fancy accessories were offered. Most Chevrons will be useable — with inaccurate shutters. I paid $90 for a mint Chevron in 1979; today good condition examples sell for $180 plus.

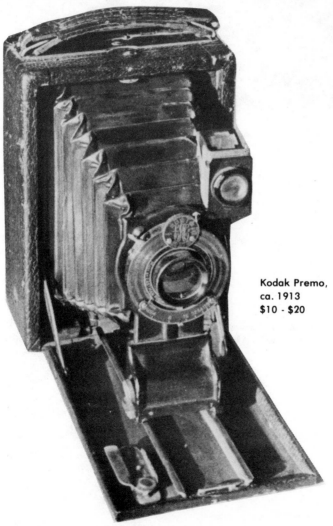

Kodak Premo,
ca. 1913
$10 - $20

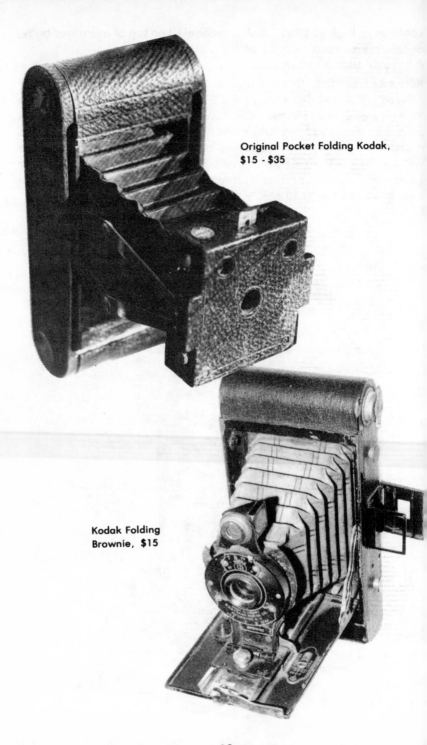

Original Pocket Folding Kodak,
$15 - $35

Kodak Folding
Brownie, $15

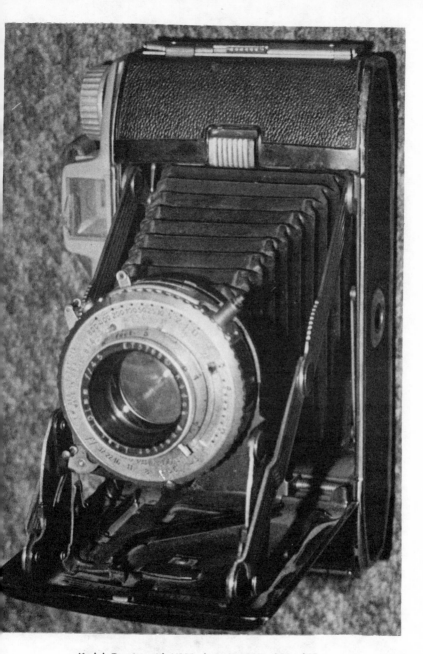

Kodak Tourist with Y800 shutter, 1951, $20 - $65

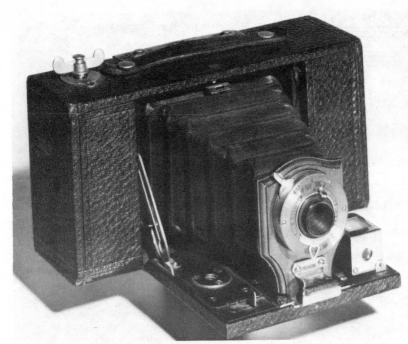

Kodak No. 2 Folding Brownie Camera, $15 - $40
Courtesy Eastman Kodak Co.

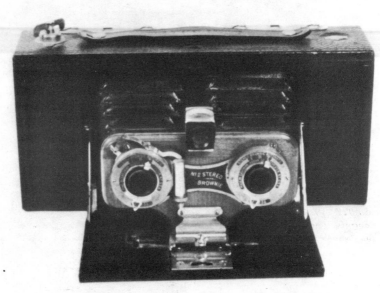

Kodak No. 2 Stereo Brownie, ca. 1909, $125+
Courtesy John Groomes

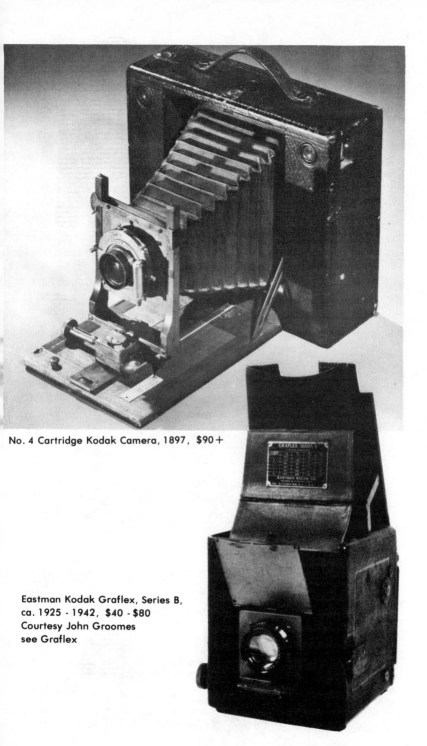

No. 4 Cartridge Kodak Camera, 1897, $90+

Eastman Kodak Graflex, Series B,
ca. 1925 - 1942, $40 - $80
Courtesy John Groomes
see Graflex

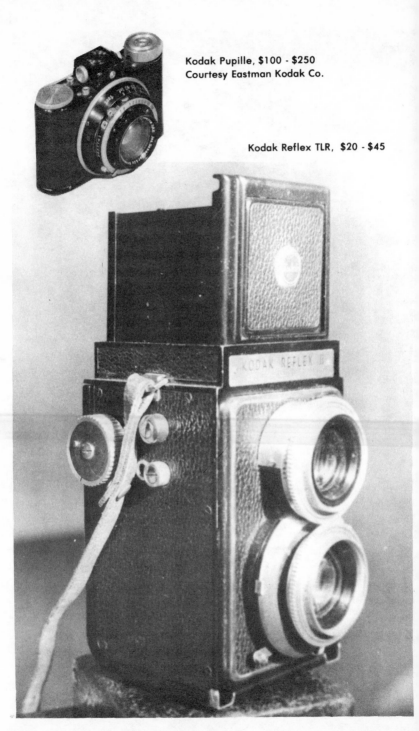

Kodak Pupille, $100 - $250
Courtesy Eastman Kodak Co.

Kodak Reflex TLR, $20 - $45

Kodak Retina II, $55+
Courtesy Eastman Kodak Co.

Kodak I-B Retina, ca. 1954, $45 - $70

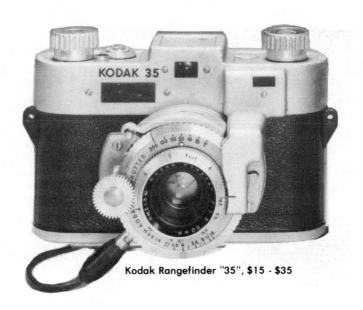

Kodak Rangefinder "35", $15 - $35

Kodak Retina II - A, ca. 1951, $55+

Kodak Medalist II
$120 - $200

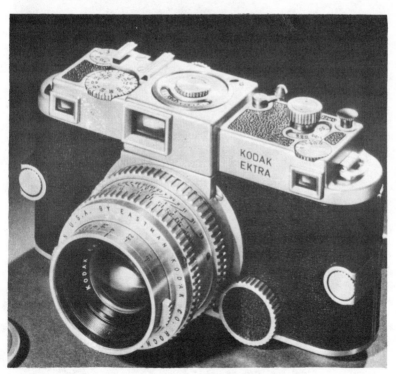

Kodak Ektra "35", $200 - $900

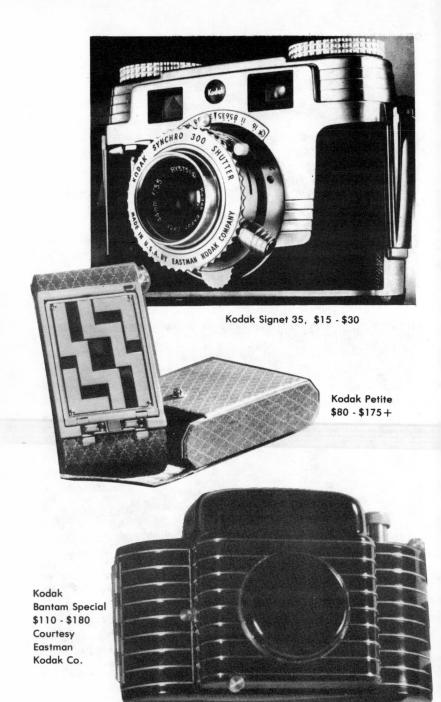

Kodak Signet 35, $15 - $30

Kodak Petite
$80 - $175+

Kodak
Bantam Special
$110 - $180
Courtesy
Eastman
Kodak Co.

KODAK EKTRA. This is the prime 'sleeper' of all Kodaks! It looks complicated — but how many sellers would know this precision camera is the finest Kodak ever made — and could hit $1,200 with 4 interchangeable lenses and case!?

The Ektra began life in 1940-41 as an American competitor to the pre-eminent Leicas and Contaxes of Nazi Germany — it failed, only because it was so very expensive ($400 in 1941, when a used 1940 Chevrolet sold for $900!), and the second world war brutally interrupted Kodak plans!

The Ektra was over-built, like the Chevron and Medalist — a thick alloy body that could be dropped from 2 stories, and suffer a 'slight' dent!

Accessories I have heard of include microscope adaptors, close-up lenses, a wide-angle and a telephoto lens, a 'passive' flash connecting to the shutter button, and a magazine back that can use single-cut films or small glass plates for medical and dental exposures!

Today, pictures taken with a post-war Ektra could beat many "35" cameras, including the prestigious Nikon and Olympus. Kodak never stinted on their lenses — though the Y1000 Ektra shutter was not trouble-free!

I've seen Ektras bought and sold for $200 (stuck shutter and scared lens) to $400 (working example, but "well-used") to $900 for a full kit, including extra lenses, in very good to excellent condition — extra for showroom shape or mint!

RETINAS. We start in the 1930's, with Retina "I" (just a viewfinder) and "II" (rangefinder) and early Retinette. Useable, but back catches are weak! Retina "I": $30 to $45, "II" model values go to $55. Retinette: $45 plus. The nice Retina line reappears after WW II as: "IA" and "IIA", most with flash sync, values to $65, either. The "IB" goes to $70. The "IIIC" has interchanging lenses, and Capital-C has same light meter and frame-lines in finder. Look for F 2.0 Xenon lens. Valued at $55 to $100 plus.

SIGNETS. The Signet "35" is common, but a nice, well-made Kodak. Ektar lens is sharp, leaf-shutter prone to trouble. Looks like a little aluminum tank — and almost as sturdy! Value, $20 to $40. Military version: (KE-7?) $80 plus. The Signet "40", "50" and "80" of the 50's are not as good as the "35", still collectible at $25 and up. As above, watch for sticky or broken shutters and film advance.

RETINA REFLEX. The 1958 single-lens reflex has leaf shutter behind an interchanging front component. EV system (like LVS) value $75 to $115.

Kodak Bulls-Eye, 620 film, 1958, $5 - $10

RETINA REFLEX S III. Made into the 60's — S lens interchange. Values go $70 to $150.

The **RAREST KODAK: SUPER KODAK 620.** I've been told that less than 1,000 were made in 1938-40. A large electric meter controls aperture — manual control is possible — with a very accurate rangefinder, sharp lens, value range — $450 to $1,000!

Kodak Super Six, $450 - $1,000

On the flea-market circuit, you're most likely to find these Kodak cameras:

KODAK BABY BROWNIE SPECIAL, ca. 1939. A bakelite-bodied cheapie, good for beginners. With still-available 127 film, these can be picked up from $1.50 to $6.

KODAK JIFFY 620. From the 1930s, these are identified by scissors struts holding the front panel. A 2-element lens and a metal body make these usable, and affordable: $4 to $10.

KODAK BANTAM F 8 FOLDER. This is mixed metal and plastic construction, made from 1939 to '47, using 828 film — just about out of supply now. Value: $8 to $15.

KODAK RETINETTE. This name of the 30's folder was re-used for a 1953 candid camera, all-metal with viewfinder, Reomar lens and 1/300 shutter.

KODAK SIGNET 80. This ca. 1959 model is the last of the Signet series — 30, 40 and 50. These early models are pretty plain 35mm, worth around $20 to $35. But the "80" features a built-in light meter, and interchangeable lenses! Despite shutter problems that plague all the Signets, the 80 could go for $45 to $60 with case and spare lenses.

And did I make fun of box cameras before? Shame! How about finding a Kodak "World's Fair" souvenir box camera? No special mechanical features, but the thin metal front with the above magic words in a sort-of Art Deco style point out a $50 to $110 collectible (depending on condition)! Around 1,000 were made in 1939.

KOMAFLEX

A Japanese 127, using single-lens reflex design. Cheap construction, from the 60's. $35 and up.

KOMBI . . . see Kemper
KONICA of Japan

Very few of these survive from the 1930's, you might see a few **PEARLS** from that era, but most will date from the late 40's and 50's. **PEARL** and **SEMI-PEARL** are folding cameras of inexpensive construction. **RANGEFINDER** models might hit $55 in price, rest with viewfinders and simple shutters would be valued at $20 and up. Look for better 1/500 sec. shutter and Postwar coated lens. Better **PEARL "III"** and **"IV"** bring highest prices of the series, with a **MINT** **"IV"** being valued over $125, with **"III"** somewhat less.

Konica III, $20 - $80

KONIFLEX. Well-made but not successful twin-lens-reflex trom late 50's. Very rare. Value, $140 to $295 or so.

KONICA 35. From 1946 models up to the one (serial numbers to 68,000) these are fairly simple in design, show better workmanship than many off-brands of the period. Values, $20 to $40.

KONICA II and IIA. Quality improves in these, with better lens and shutter quality and flash sync. These rangefinders offered a F 2.0 lens in the "IIA"; both have 1/500 leaf shutters. Values range, $30 up to $65 in good operating shape with case.

KONICA III and IIIA and IIIM. All these have the film advance lever on front of body (this may stick). The "A" and "M" have paralex lines showing in rangefinder window and I've seen a close-up kit (add-on lens attached to rangefinder magnifier). The F 1.8 lens is sharp on these, but like many 50's Japanese products, the shutter will be the weak point. Neglected "III's" can go for $20, while one in perfect mechanical shape with case would be worth $80.

KOZY CAMERA of Boston

The only model I know of is a very rare book-like folding camera, the tiny lens peeping from the 'spine'. All leather covered, used wide roll film; I've heard of a cut-film model. From about $10 when new, these go up to $500 in Very Good shape, higher for Mint and case.

KRAUSS of Paris

The **TAKYR** is the only affordable model you'll encounter. From 1905, a folder with focal-plane shutter, very good workmanship, fairly rare. Valued at around $140 to $230.

KRAUSS of Stuttgart

A couple of folding, cut-film models were made in various sizes. Figure $30 to $50.

PEGGY I and II. These very rare 35's from the early 30's differed in "II" model offering a built-in rangefinder. Compur shutters and

various lenses, Tessar, Schneider, Xenar, and most prized, a F 2.0 Xenon. Avoid Radionars or F 4.5 optics — they're probably 'replacements' by some amateur repairman, and would lower value. Value, "I" — $290, "II" — $490 and up.

KRUEGNER of Germany

DELTA and DELTA KLAPP. From around the turn of the century, both use cut-film or plates, as did the **PATRONON** model. A **PERISKOP** Model is the most common, and valued at $80 and up, while the others range in value from $100 to $150 or so. A seldom-seen roll-film camera from the early 1900's would have a value of around $100 also, more for Mint condition and case.

Very rare **STEREO DELTA** from circa 1905 has sold for over $500.

WALTER KUNICK of Germany

In the 1950's, a **PETIE** sub-miniature for 16mm film was marketed. Simple lens and shutter, not a useable camera like the Minox, et al. value, $30 or so.

A Petie model shaped like a cigarette lighter was briefly marketed. Not mechanically impressive, but 'novelty-camera fanatics' have driven the price up on these, as all disguised or detective types: $235 in Near Mint, case extra. I've heard of but never seen a Petie 16mm camera that was built into a woman's compact! Very rare — perhaps they were all snapped up by Cold War spies!? I'd guesstimate $300 value.

A good rule-of-thumb with miniature-spy-detective cameras, is don't gamble until you've cross-checked value and identification from several sources! Unless you want to specialize in this field, you can spend a lot of time puzzling over these, especially if there's no Brand name on the camera — I've seen several examples like these, probably Japanese. AND, they're not so easy to sell — except to specialty collectors!

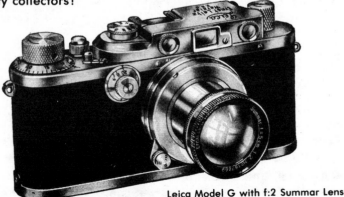

Leica Model G with f:2 Summar Lens

LANCASTER of England

Few of these have been imported into the United States.

CAMREX AND DELUXE MODEL. These are folders made of fine wood, usually mahogany, often with tan or red bellows. From the turn of the century, you might be able to pick up one of these at a big-city show. Usually in 3 x 4 and 4 x 6 sizes. Values, from $140 to $235.

OMNIGRAPH. This is a rare leather-covered box, that used a simple guillotine type shutter mounted ahead of the lens, giving three speeds, powered by a rubber band! From 1895 or so, the Omni is prized, but not yet museum bait. Values hover around $200.

INSTANTOGRAPH. These were a cross between a tripod-view camera and a portable model, or hand-and-stand. Very nice looking, with brass hardware, red bellows, etc. Often the shutter is mounted ahead of the lens, and lens, if authentic, will often be a barrel type with 'Waterhouse' stops. Fairly rare, at $175 to $255.

LEADER

By an unknown (to me!) Japanese maker during the 50's. A plastic-bodied stereo. $45 plus.

LEICA of Wetzlar, Germany

This firm is really responsible for the creation of the modern, mass-produced 35mm camera. Oscar Barnack's first production model, the "A" is now rare and very collectible, while tens of thousands of later models are still available, affordable and usable.

I will not discuss at length the incredible variety of odd and unusual Leicas — you will likely never encounter them. They include the **LEICA B**, with an outside Compur shutter (no focal plane). This 1929 creation is worth over $2,500 to collectors. An incredible **250-EXPOSURE LEICA REPORTER** goes for almost $3,000, a **LUFTWAFFE-ELGENTUM**, $600 plus, a "**K**" or "**WH**" marked model, $750 to $1,000, a **U. S. QUARTERMASTER-DECAL** model at $450 plus, or one marked "**MONTE**" or "**JARRE**" - $1,900 plus! I have seen a **few** stereo attachments (Steroly) - for $1,200 plus for the full kit!

While I like and use my 4 Leicas, there is a bit of sophisticated mania over this brand that can be a **little** quirky. Treat the Leica as the great collect-or-use camera it is and you'll be okay.

LEICA A. No rangefinder, 1/20 to 1/500 shutter, serial numbers up to 60,000. Body only $340 plus. With the ordinary 50mm Elmar, value: $430 to $550 plus.

LEICA C. Numbered 60,000 to 72,500. A small viewfinder and square accessory shoe. $285 to $380.

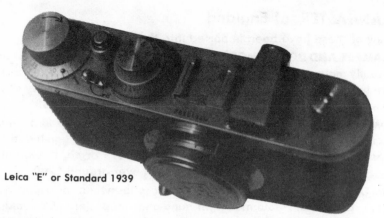

Leica "E" or Standard 1939

LEICA D or II. I have 2 of these. The squinty rangefinder makes it a nice usable model — black body preferred, as most Leicas, over 52,000 were made, many survive. Again, most have "Elmar" lens. Value $180 to $240.

LEICA E STANDARD. This ia a retake of the "C" — no rangefinder. Most are chrome body. Made from circa '33 to 1946. There are rare variants, which most folks will never see. Values range from $275 to $330 or $380.

LEICA IIIA and IIIC. Common models. The "IIIC" has a ball-bearing equipped shutter. These were supplied to the Whermacht and Luftwaffe in great quantities — lots of American G.I.s took 'em home. I've paid $50 to $100 to $150 for mine. Prefixes "Fl" or "K" indicate military models, as do grey enamel and red curtain. Snap these up for a modest price, if you can - but don't gamble. I.D. feature: slow speed dial on all models. Values, $85 to $145 to $180 with case.

LEICA IIIF, IIF. The "IIIF" has black dial, value $140 plus, while red dial model has a self-timer — $160 to $220. The "IIF" has no slow speeds, value $150 plus. These are fairly common. Also finally, built-in flash-sync!!

LEICA IIIG. A nice modern collectible — larger, brighter rangefinder, different body from all other "III's". Over 40,000 were made. This 1957 to '60 camera goes for $350 to $490 plus; the case alone can sell for $20!

LEICA M-3. The last, in my opinion, of the old, collectible Leicas. This sleek-looking "M-3" is almost always in chrome body, uses a bayonet mount on its lenses — all previous use a 39mm screw-type mount. Early models take 2 strokes of the (at last!) lever-type film advance, later — single stroke. Prices range: $300 (body only) to $410 with a Summitar, or Elmar, to over $500 with Summicron, in perfect condition with case.

LEICAFLEX. A modern SLR of the 60's. Used price, $280 plus, mint.

Now, there are "E. Leitz Wetzlar" lenses found often for sale by them-selves. I've encountered: 35mm Elmar F 3.5 wide angles at $50 plus, 50mm F 3.5 Elmar, $45 plus; Summar 50mm F 2.0 (a poor design, not prized), $30 plus; a rare 50mm F 2.5 Hektor at $90 plus; 50mm F 2.0 Summitar (common - I own 4) at $40 to $60; telephotos - 90mm Wollensack at $85 plus; 90mm Elmar at $70 plus; a 127mm Wollensack at $100 plus; and rare models: 125mm F 2.5 Hektor, $200 plus; and 105mm F 6.3 Elmar for $450 plus.

The number of accessories are incredible, and include close-up kits, motor drives, add-on reflex housings, and 1930's and 1940's flash synch, base-plates, ranging in price from $5 to $2,000 and up! The name E. Leitz is like the word Cadillac among camera collectors.

Best Best: Any "IIIA" or "IIIC" with working slow speeds, and a coated F 2.0 Summitar lens . . . or a "IIIF" with flash sync for more.

P.S. Your Leica won't be **usable** without a take-up spool and a lens cap. Then, **make** the seller show you how to load the film on these tricky little devils . . . ! With that and a little practice, you can go out and shoot covers for LIFE magazine!

LEIDOLF of Germany
This firm made the **LORDOMAT, LORDOMATIC** (built-in meter) and **LORDOX.** All are middling-quality 35mm models of the 50's. The Lordox is cheap and simple at $20 and up value, while a mint Lordomat with functioning rangefinder and lens attachments might hit $65!

LENINGRAD
A Russian-made Leica look-alike. Workmanship crude, not rare, though motor drive is prized. With F 3.5 lens, value around $100, while motor drive, or extra lenses: $190 and up.

LEROY AND LEUCCIAR. Both of Paris
These firms both made stereo cameras. The more valuable LeRoy ($200 and up) can take stereo pictures as well as stereo, while the Leucciar is simpler in construction, and less prized, at around $125 or so.

LINEX . . . see Lionel

LINHOF of Munich, Germany

This old-line firm was making cameras into the 1960's. A circa World War I model, the **SILAR**, was a well-made camera taking 9 x 12 and 10 x 15 exposures. Values $85 to $130.

Most of the Linhof you'll run into will be the **TECHNIKAS**. All are known for fine workmanship — and high cost. Many lenses and film sizes will be noted — Linhof did not make their own lenses. A "III" and "IV" model were made from the 30's into the 40's, and much more sophisticated models from the 50's and 60's are in daily use by pro photographers! Most Linhofs have rising, falling and even swinging fronts and backs. The film size 4 x 5 is more prized, being more usable for Americans than the 9 x 12 cm models. Depending on condition, and extras such as fitted rangefinder or extra lenses or roll back, values: $160 to over $500, with full-tilt modern kits easily passing $1,000.

LIONEL CORP.

Besides making very nice trains, this company found time to turn out the **LINEX**, a 16mm stereo camera, of mixed plastic and metal construction. This could be a rewarding 'sleeper' collectible, as it doesn't particularly look like a camera — it could easily have come off the starship Enterprise! I once nabbed one for $20, but present day value would be nearer $100 or a little more.

LIZARS of Glasgow

From Scotland with love came a range of fine cameras. A natural wood-finish **TROPICAL** at $700 plus or a **STEREO** model would be beyond most of us, but the few **HAND-STAND** models are encountered here and there. Leather-covered wood and brass or nickel brightwork make them handsome display cameras; many lens and shutter combinations were fitted, from Kodak Anastigmats, Aldis (so-so) to English Cookes and Rosses (better), to Zeiss and Goerz optics (top). These early 1900's models are valued at $110 to $230, depending on lens and condition.

LUMIERE of France

The **ELJY** is most encountered, a small 30's vintage 35mm camera with lens and rim-set shutter on a pull-out mount. Value, $45 to $90. **STERELUX LUMIERE.** This 20's stereo camera was all-metal construction, used 9 cm wide roll rilm. Priced at $170 to $230 or so. Other relatively simple models were folders and boxes, using roll film; these go for $15 to $25.

LUTTKE of Germany

Around the Kaisers time, this small firm made several models of folding cameras of nice appearance, but ordinary design. Prices vary: $45 to $80.

MAMIYA of Japan

The earliest examples of this firm I've seen date from the end of the Korean War, when journalists and sight-seeing GI's brought back products of this and numerous other companies, and brought them back to the States, starting a demand that had not been there before, due to bitterness against the former enemy, and poor workmanship of many Japanese products of the 1940's. The Mamiya and Nikon and Konica and Canon and others later changed all that with increasingly well-made products . The rest . . . is modern history.

MAMIYA 6. This squarish-bodied rangefinder uses 120 film for 12 exposures. An unusual feature is the focusing — the film plane inside the camera body moves, while the lens stays stationary. If you find one of these, the shutter (early, 1/200, later 1/400th sec.) will probably not work well, a shame because the lens on this model is excellent. Value, $45 to $80.

EARLY MAMIYAFLEX. No interchanging lens board. I have never seen one, price would probably be similar to old 50's Minolta Cord or Kalloflex both rough - like TLRs. $40 to $90?

MAMIYA FLEX. This is the 'dad' of the present day Mamiya C-330. It also has an interchanging lensboard, and a square 2¼ x 2¼ inch exposure. Good workmanship — a collectible that is also usable. From 1955, prices range $80 to $135.

MAMIYA 16. This sub-miniature is similar to the Minolta 16 and other Japanese models. Not very rare, workmanship fair only. Valued at $25 to $35.

MANHATTAN OPTICAL of New York

The most well known Manhattans are the **BO-PEEP** (yes, that's right!) and the **KORONA** and the **WIZARD**. All are handsome folders, for various film sizes up to 5 x 7 inches. A **KORONA STEREO** is prized, at $220 or so, while the other folders hover around $55 to $70 with a little more for Mint shape and case.

A **NIGHT HAWK DETECTIVE** used a string-setting shutter like very early Kodaks, and is rare in leather-covered (good) or bare wood-finish (better). Prices: $270 or so for former, $300 to $380 for latter.

A special Long-focus Wizard pops up occasionally. This triple-extending monster is rare, so goes for $110. Most Manhattans cannot be identified without the little name-plate from the numerous Senecas, Chatauquas, Rochesters, etc. that competed with Kodak in the 1890 to 1900 period.

MARIONS of England

The only product of this company I came upon is the **SOHO REFLEX** . . . very similar to the Graflex, and Thornton Picard Ruby. The Tropical is rare, but leather-covered models are found, circa the 1920's, for 3 x 4 and 4 x 6 inch exposures. These heavy cameras are mechanical classics — as you'll find out if you ever have to have one fixed! But these heavy (3¾ lb.) single-lens reflexes are bound to appreciate in value. Look for Goerz or Dallmyer F 2.9 lenses! Values are high, from $280 for a scruffy, barely working example, up to $540 or so for Very Good plus, more for Mint. The very rare Tropical, bare finished wood, often teak — $2,000 and up!!!

A **MARIONS DETECTIIVE "RADIAL" MODEL** is occasionally seen, for 4 x 6 inch exposures on magazines or plates. Values, $225 to $450.

MacKENSTEIN of France

Several models of stereo cameras are seen from time to time, date from turn of the century. Prices range, $140 to $220.

MEC 16. This well-made subminiature dates from the 50's and is superior to many competitors. This company also, I'm told, made a tiny enlarger for the camera, and accessories like filters and a flash gun! This German product goes for $25 to $40, more for various add-ons.

MEOPTA of Czechslovakia

From this war-torn country came many unusual cameras in the 40's and 50's, including a strange Twin-lens-reflex (see **FLEXARET**). The **MIKROMAS** are well-known — both standard 16 and a stereo 16! Both are far superior to Japanese competitors like the Hit, etc from Japan, but less in demand than the Mec or Minox or Gami in the 16mm field. Either Meopta model sells for $110 to $230, more for accessories.

MICK-A-MATIC

Plastic horror shaped like Mickey Mouse's head! For 126 film. Valued at $20 to $40.

MIMOSA

A line of German 40's vintage "35s", fair to poor workmanship, that were selling for $29 at Willoughbys in the later 50's. Rare today, at $70 to $140 or so.

MINOLTA of Japan

A pre-WW II folder for 120 film is told of, I've never seen one. Probably like the Lyrax and others, modeled after German models. The most respected 1939 Minolta is a copy of the Paubel Makina called the Press. It is very well made, in chrome finish, with war-time models having internal flash sync, and a good 1 400 sec. shutter. This range-finder rarity goes for $110 to $255!

MINOLTA SEMI. A 50's 120-film folder, modestly rare at $35 to $50. Also, a '53 or '54 **MINOLTACORD TWIN-LENS** is sometimes seen — plainer than later "Auto" models. Value, $60 or so.

MINOLTA AUTOCORD. A nice Twin-lens-reflex from the 50's, with 1 500 shutter, made in a variety of models, lettered, A, B, etc. up to Q(?). Accessories include flash and close-up press-on lenses. Valued at $45 (early model, fair shape) to $130 (later 60's vintage, Mint).

MINOLTA 35. This was a Leica-resembling rangefinder model, with a (usually malfunctioning) focal plane shutter, and screw-mount interchangeable lenses. From $20 in Poor shape, a Mint model might fetch $80.

Some people consider the very early (1958 or so) **SR-7 and SR-3** Single-lens Minoltas collectible, but they're really just good used cameras, look very much like the 1980-model Minolta SRT 102! Values, $70 to $135.

MINOX from Germany

Minox B 16mm, West Germany, $50

Another '16', this one going through many different models — the "B" is common, the "IIIS" better and prized. Black bodies add value in

all cases. Some prices: Chrome B . . . $30 to $50. **MINOX C,** chrome $110 and up, black body, $140 and up (black Minox "B" similar prices) Minox "IIIS", chrome, $80, with black body, $255 and up.

The RARE original Minox was made in 1938 in Latvia. Identify by Riga, Latvia marking, and stainless steel body, (brass core), and L-E-T logo. Worth $400 and up, if you ever see one!!

MINUTE 16 . . . see Universal Cameras

MIRROR REFLEX

This early American single-lens reflex is rare, but not mechanically sophisticated. Made about 1910, leather-covered wood body, made 5 x 7 exposures. Prices encountered: $55 (poor; to $140 (Mint with case and holders). I believe this is the only model Hall Camera of Brooklyn ever made — and also the only camera ever made in Brooklyn (the fifth largest city in America!).

MOMENT

From Russia in the 60's, a poorly-performing copy of a Polaroid 95, big and clunky. Valued at $45 to $85.

MONROE CAMERA of Rochester

This little firm was gobbled up by the forming-Rochester conglomerate in 1899 or 1900. A line of compact folding models are prized. Flat, full-width lens standard snaps back into body by scissors struts. From 2 x 2 to 2 x 3 to 3 x 4 inch exposure sizes. Rare, so values run from $90 to $190 and up for the 3 x 4 called the **MONROE POCKET POCO.**

A 4 x 5 and 5 x 7 **FOLDER** was made; I've never encountered one. Values are said to be in $80 to $145 range, for this conventional, drop-bed model.

MULTISCOPE of Burlington, Wisconsin

The **AL-VISTA** panoramic camera is the only Multiscope I know. A friend of mine actually used one of these as late as 1979, to take a picture of his family standing in front of their swimming pool! A set of gears and a spring turns the simple lens around. Values, $150 to $245.

MURER of Italy

EXPRESS. A box-type camera from the turn of the century for film magazines, and rare. Valued at $90 to $150.

FOLDING MURER. Many models of this were made, look like a big Ensignette or early Tenax . . . lens cover raises up to serve as view-

inder. Used a focal-plane cloth shutter. Prices range: $140 to $235.
 stereo is seldom seen, rumored to be inferior to Richard, but very
are, so prices approach $255 to $340.

MYCRO AND MYCRO MIRACLE, by Sugaya of Japan

hese 50's miniatures used 16mm film. Very crude shutter hides
nder stamped metal body. Mostly novelty value makes these worth
15 to $25.

NAGEL of Germany

his respected firm was bought by Kodak. Many cameras made by
agel were continued by Eastman into the 1930's, including
ecomars, Pupille and Vollenda. See the Kodak section for values.
agel supposedly bought Elmar lenses for not only his **PUPILLE** ($300
lus with Elmar) and **VOLLENDA** (less rare) but also the **RECOMARS**,
oth "18" for 6 x 9 cm and "33" 9 x 12 cm! These are very rare, either
ould be worth around $255 in Very Good Plus condition, with
mars.

RANCA model was made by Nagel; I've never heard of these being
-issued under Kodak name. Used Nagal Anastigmat lens in
rdinary shutter — value about $180.

agel made a lot of folding models for both cut-film and roll. They're
eautifully-made, but not super rare. I'd price these at $40 to $75.

NATIONAL COLOR CAMERA

om the 30's, similar to Curtis and others, with multiple filters, etc.
ard to re-sell; look for Goerz lens. $230 plus.

NEWMAN & GUARDIA of London

ese rare birds are unusual in design, with garden-gate scissors
ruts, aluminum bodies. The 'Baby' used roll film, Baby Special,
ates. I'd say value $100 up to $255.

& G REFLEX. This is very rare, uses an efficient but complicated
cal-plane shutter, has scissors struts, and a TILTING lens-board!
alues vary: $100 to $240.

NICCA of Japan

nown for a Leica imitation, inferior in quality to the original, but
tter than Fed. From '49 to '55 or so, several models were offered.
lf-timer and working flash sync would add to value. Prices range
om sticky-shutter models at $70 to Mint working condition with
se: $145.

NIKON of Tokyo, Japan (originally Nippon Kogaku, changed name for 'buyer acceptance')

NIKON 1 and M. These are rare, few brought into America. Work manship is not up to later "S-2" standard. ID for "1" — exposur counter goes to 40. I'd pay $110, maybe, for either model in FIN working order only!

NIKON S. Differs from above in having a little two-prong flash outle on left side. Like above models, has cloth focal-plane shutter to 1/50 second. First Nikon to have characteristic twin bottom locks. Value $140 for nice shape and F 2.0 lens and case. For better F 1.4 lens, ad $10 to $25.

NIKON S-1. I've heard of, never seen, this model. Value would b similar to an "S".

NIKON S-2. The top contours changed here, for a bigger range viewfinder, and a rapid-wind lever is added. Flash sync become normal. Chrome model, $125 to $240, with F 1.4, more for Min condition overall. A rare black body would add over $220 to value

NIKON S-3. Rarer than preceding, has lines in viewfinder for thre lenses. Chrome, figure $330 and up with F 1.4, while black body an Mint shape might push this to near $640 — mostly among "Nikor Fanatics".

NIKON S-4. A rare model, that has no self-timer (?). No idea as to fair retail value on this one!

NIKON SP. Much re-designed range-viewfinder covers 5 lens field and this and "S-3" have self-timer. Provision for motor drive. Man collectors consider this neck-and-neck with Leicas M-3 as th Ultimate rangefinder "35"! Chrome bodies bring around $430 in nic shape with case - black bodies with lens, $850 or so!! Note: M favorite Nikkor lens is the F 1.4, with a F 2.0 second. The 'Fast' F 1.1 over-rated!

NO DARK

This ferrotype American camera came out around the turn of th century. A long, rectangular wooden body in natural finish hold individual tintype plates. Simple lens and shutter. Rare, valued $230 to $500.

OLYMPUS

A few folding cameras show up from this Japanese company, wit good Copal shutters and sharp lenses. These 50's models would brir $15 to $50.

PEN. This is the prized offering by Olympus, starting with the original model, and the "D" and "D2" and "S" and "W", all view-finders, with the "W" offering a built-in wide-angle lens, the "D" and "D2" having built-in meters. All these 'half-frame' cameras are light, might still be good picture takers if the shutters aren't kaput. Values, any $35 to $65.

PEN F. This one is the 'modern' Pen with single-lens reflex focusing, interchangeable lenses, and even later (the FT model) a built-in meter. But the meterless "F" is prized, especially the black body. For your 18 x 24mm exposures expect to pay $115 to $185 — but beware of malfunctioning shutters. I've seen black "F's" hit $300 with one extra lens and case, more for Mint condition.

OMEGA 120 by Simmons

Unusual design rangefinder press camera for 120 film, featuring push-pull lever for film and shutter advance. After the 50's, Konica bought the design and made the famous Koni-Omega. Values: $90 to $185.

ORIONFLEX

Japanese 50's TLR. Value around $20.

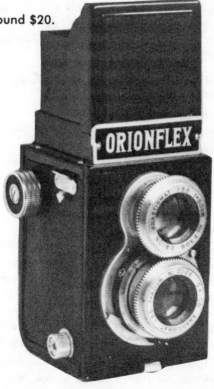

Orionflex TLR
$20 +

PATHE MOVIE
This French 9.5mm camera is common — $40 plus.

PEERFLEKTA TWIN-LENS
These are inexpensive TLRs from the 1950's. Prices range: $7.50 to $20.

PENTACON of Dresden, Germany
This East German firm made the first 'modern' eye-level single-lens reflex, introduced in late 1950's in the Russian-controlled Jena Zeiss factory. This "S" model is valued at $140 and up.

CONTAX FB. Later version, had 1/1000 focal plane shutter. Prices range from $65 to $90.

PENTACON. Various models of this single-lens-reflex are known for cheap workmanship and sticking shutters. All can be purchased for $45 to $90.

Pentacon and East-Germany Jena Zeiss waged a long copyright war in the turbulent late 1940's . . . many were made with no name-plate, or "Made in USSR Occupied" printing on them. I've heard of a Hexanon model that ususally comes with a thin name-plate glued on! Generally, these cheap and unreliable cameras are not worth gambling with!

PERFEX, Candid Camera Corp., America
PERFEX 44. This model had a focal-plane cloth shutter but poor workmanship, like other Perfexes. Pre-war model used interchanging screw-mount lens, all-metal body, and dim rangefinder Values, $45 to $85.

PERFEX SPEED CANDID. Also pre-War II, with a 1/500 top shutter speed. From a $50 price at Willoughbys in New York, the Speed Candid, with usually stuck shutter goes for $40 to $55 in most markets!

PERFEX 33 and 55. These focal-plane shutter models ran from 1939 into the later 40's; the "55" had an extension meter. Either can go for $25 to $60, depending on condition.

PERFEX 101 and 102. These post World War II models gave up the poor-design focal-plane shutter, sported a lens and leaf shutter stuck onto the all-metal body. Some 102 models may have a Ektar lens — better than most. Neither is anything to write home about — a good beginner's collectible, at $30 to $45, $60 mint with Ektar.

On these Post-War Perfexes, flash sync helps value. Also, there is an easy-to-lose film take-up spool, that always falls out when you

remove the camera back. I have heard of, but never seen, a "103" model with Ektar lens and Compur shutter that ALMOST works most of the time, and might hit $50 in value — with luck!

The Perfex was the most prominent among challengers to fine European cameras, like the Detrola and Clarus "35" and Vokar, etc. Only the old reliable Mercury ALMOST made it — the rest faded into obscurity. They could not compete with Post-War German and Japanese products, or the Yellow Box Gang's Signet "35" and Argus C-3 — these latter products worked!

PERIFLEX made by Corfield of England

A 35mm camera that used a tiny periscope for fine viewing! An unusual 1959 to ? production, and rare. There are "I", "II" and a Gold Star model made in Ireland! The focal-plane shutter and interchanging lenses put it in the quality category, and early models use Leica-threading, for interchangeable lenses! From the $50 I paid in 1979, present values range from $140 to $230, with case, and more for the eccentric spare lenses. As with other VERY strange brands, repairs might be almost impossible . . . !!

PERKA of Munich, Germany

PERKA FOLDER. This well-made 20's model has a tilting front for taking architectural photos! Otherwise, similar to many other folders of the period. Value, $95 to $145.

PETAL Japanese

Ca. 1950 miniature, watch-shaped. $90 plus. Earlier hexagon shape model is rarer.

PHOTO-SEE

A 40's American 'instant picture' model. $20 and up.

PHOTOVIT . . . see Bolta

PIGNONS of Switzerland . . . see Alpa

PITTSBURGH ULCA

A unique design camera, taking 20mm exposures. Simple lens and shutter. $25 and up.

PLATOS of Paris, France

A line of folding cameras, based on German design, and seldom seen. A scissors strut model is prized, in 6 x 9 and 9 x 12 cut-film size. These 20's vintage models are valued at $80 to $120.

PLAUBEL of Frankfurt, Germany

All these press-style cameras of the Makina line had a full-body-width lens standard popping out upon strut arms. The 1920 to '32 **MAKINA I** is all-black and rare; has a dial-setting Compur shutter. The later 1932 model has a rim-set Compur, and the front lens element interchanges for wide-angle and tele components. Non usable, but collectible at $100 to $150.

MAKINA II. These were made in several varieties from 1933 into the postwar years. All feature a rangefinder, and the "II's" offer various methods of interchanging lenses. Values, $145 to $280 plus.

MAKINA III. These postwar models are attempts to modernize, but none can compare to a Speed Graphic or other competitor in overall usefulness! The "III's" and IIIR models have shutter speeds up to 1/400 second. Values: $140 to $220, more for any extra lenses or a roll-film back.

BABY MAKINA. This was a scaled-down model, taking 6 x 4.5 mm exposures, and is rare. Valued at $120 to $195.

MAKINETTE. This used 127 film; a finely made folder and rare. Prices encountered: $340 to $550.

ROLLOP. Looks like a Zeiss Ikonta. Folding bed design, and rangefinder. Values, $100 to $150.

PLAUBEL STEREO. Very rare, resembles Makina models in construction. Dial-set Compur shutters, circa 1930's. Valued at $440 to $700.

All Plaubels are known for eccentric design and a line of Anticomar and Orthar lenses that did not measure up to Zeiss in quality. The relatively common Makinas are found from time to time, but are not easily re-saleable. It's best not to tie up a lot of money in this or other odd-ball designs, unless you simply fall in love with a particular camera at first sight.

POLAROID of Cambridge, Massachusetts

These are common and only 1 in 10 have a chance of being valuable!

POLAROID 110 "A" and "B" and 120. These sophisticated models use 'normal' lens and leaf shutter, with range-finder. They use 42 or 47 roll-film, rare but sometimes available. These early 50's models sell for $35 to $90.

POLAROID 180 and 195. These cameras also use a conventional lens and shutter with rangefinder; the 195 can take more modern pack film. Used by professionals as well as collectors. Prices encountered $115 to $210.

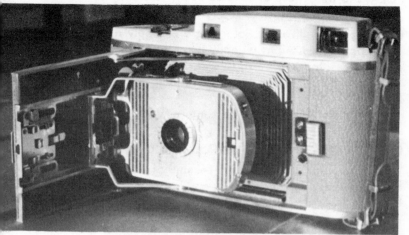

Polaroid No. 800, 1958, $7 - $10

Polaroid
J-66
$10

POLAROID 95. This large, clunky model was the first Polaroid, introduced in 1948. A little wheel sets 'light-value' numbers giving various lens and speed combinations. All-metal body, covered in grey or beige imitation leather. $15 to $30. These are NOT rare, and are not useable; a marginal collectible at best.

POLAROID 80. These are scaled-down versions of the 95, from the 1950's. Using 2 x 3 inch obsolete film. Values, $10 to $20.

In my opinion, all other Polaroids are simply not worth bothering with. The SX-70 or Alpha is really a modern camera, and available at many stores, marked down to $40 to $70.

PRESS KING
A postwar Canadian journalist camera. Value, $100 plus

QRS CAMERA by DeVry of Chicago
This rectangular, plastic camera resembles the original Ansco Memo. It was designed for cinema film, and had a small metal film advance lever on one side (often missing). But the lens and shutter weren't just simple, they were crude, and the photos obtained were usually awful. This 1928 creation petered out soon; today they are moderately rare, bring $25 to $50.

QUAD CAMERA by Close & Cone of N.Y.
A box camera from ca. 1897 that used a single film holder, giving exposures. No focus, single speed shutter. Value today, $35 to $65

RAY CAMERAS, also known as Muschler & Robertson Co., N.Y.

Ray "B" Box
$20 - $40

This firm made two or three folding cameras of conventional design, often with red bellows, for cut-film or plates. These 1900-vintage models would sell today for $35 to $50.

A Ray box camera was made in several variants, these have no special features, resemble Rochester and Western boxes, single speed shutters, no focusing, etc. Values range: $20 to $40.

RECTAFLEX

This Italian Single-lens-reflex from the 50's boasted a cloth, focal-plane shutter and interchangeable lenses by 'Pentax' type screw-mount. Many lenses available, including better Augenieux and Zeiss Biotar. Shutter not known for durability, so this brand did not sell well. Values, $100 to $150, more for case or Mint condition with Biotar.

REFLEX CAMERA of Newark, N.J.

JUNIOR REFLEX. From 1904, this single-lens reflex did not focus, but offered a variety of shutter speeds, two-element lens, for cut-film or plates. Fairly rare, so prices range $115 to $180.

REFLEX 4 x 5. Two models were made around 1898 to 1900, earlier is rarer, valued around $340 (Very Good plus), while a later version with tall viewing hood, a la Graflex, goes for around $220 or so. Both have focusing and variable shutter speeds. I've seen these with Kodak, Bausch & Lomb, and Non-Name Anastigmat lenses.

ST-41 Realist Stereo, $95 - $150 see David White

REID CAMERA made in England

A Leica copy with built-in flash sync, good workmanship and finish. Value, $190 to $235 or so, more for Mint with case.

REVERE STEREO

From America in the 50's, a decently-made all-metal stereo for 35mm film. Revere also made viewers and projectors; these made more money in the marketplace than did the camera itself. Value today: $80 and up.

Reitzschel "Kosmo Clock", $100 - $200. Photo by Bruno DeGrassi

"Reko" American Folder, ca. 1905, value $30 - $45.
Photo by Bruno DeGrassi

REVERE 127. This late 50's creation had a built-in flash, a nice range-finder, and a light meter. All-metal, for 127 film. Rare, because they were over-priced and did not sell well. These range widely: $20 to $60 (my own was scooped up at Salvation Army for $5 in '79).

REX CAMERA of Chicago, Ill.
I've only encountered a 4 x 5 magazine camera, with single-speed shutter, no focusing, from circa 1900. Value $40 to $65.

RICHARD VERASCOPE from France
This all-metal stereo used 7.5 x 13 plates, had variable shutter. Richard made this model for many years, so it is common among French Stereos of the period, 1905 to 1920 (?). Prices, $90 to $155. A **HOMEOSCOPE** is similar but rarer, might go to $195 or so. A simple-design **LEGLYPHOS** was made around the turn of the century: $85 and up.

RICOH of Japan

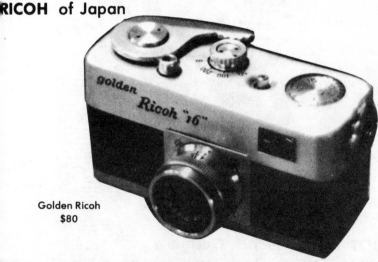

Golden Ricoh
$80

RICOH 16. From the 50's, a small "16" well-finished with viewfinder. Nice lens but weak shutter. Value, $40 plus. A model with thin gold-wash is rarer at $80 plus.

RICOLET 35. A viewfinder model for the same period. Lightweight, medium quality, with ASA flash, for "35" film. $30 to $50.

RICHOFLEX. Many models, from "A" on up were made, they are simple in design but decent picture-takers, later models have flash sync, good lenses. Avoid the light-meter equipped **DIACORD L** — it had many mechanical problems. Prices vary: $15 to $50 or so. The

un-metered **DIACORD**, however, is a good camera, with sharp lens and unique see-saw focusing levers. Value $45 plus.

Richoflex, ca. 1950, $15 - $50
Photo by Bruno DeGrassi

ROBOT of Dusseldorf, Germany

This 1934 firm began making motor drive in conjunction with 35mm film over twenty-five years before the Nikon appeared with their motor drive! Many thousands of these cameras were used by the Third Reich armed forces during World War II, especially the Luftwaffe. Robot cameras were well-finished and highly respected for their design.

ROBOT I. This earliest version used two film cassettes, winding the film from one to the other — no re-wind! Used Primotar or Tessar lens, and took 24 x 24mm exposures, with 24 exposures on one winding of the spring-drive built-in motor. Viewfinder swivels, for 90

116

degree pictures. Wind-knob at top center of camera body. Today, values range from $140 to $195.

ROBOT II. This 1939 to 1950 model had flash sync, and the exposure counter is from 1 to 55. Slow speeds go down to ½ sec. Botar lens is preferred. Prices range from $115 to $210.

ROBOT IIA. This version uses normal film cassettes, as well as the special Robot cassettes. Appears mostly with Xenar and Xenon lens, and a double-spring motor lets user take 48 pictures per roll! But still — no rewind handle! Values go from $135 to $230. Look for "k" or "WH" for military models.

ROBOT STAR. This is similar to the Robot Junior of about same era (1953 to '59), but the Star has a rewind handle. Comes with Xenar, or the better Xenon. Value, $115 to $225, perfect condition with case!!

ROBOT 36. This model, unlike previous, has no provision for bursts of shots — only single shot. Was made into the early 60's, and is currently prized as a very usable and modern camera, due to rapid film advance. Prices go to $340 with F 2.0 Xenon and 75mm telephoto lens, in Mint condition!!

ROCHESTER OPTICAL

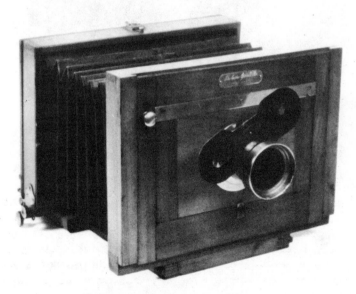

Rochester Optical, folding plate view camera, ca. 1890
Courtesy, John Groomes

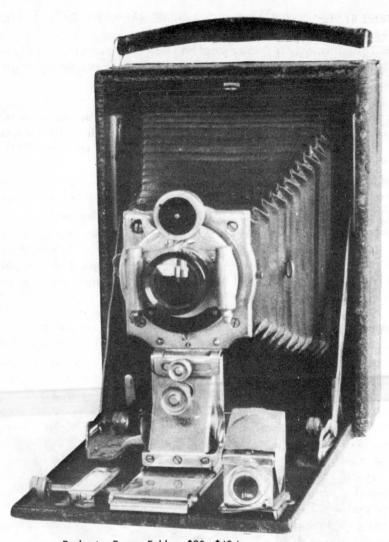

Rochester Premo Folder, $20 - $40+

A large and prolific American maker from New York State
eventually becoming a part of Eastman Kodak around 1907.
estimate over 1,000 products of R.O.C. are still drifting around –
they are not gold-plated rarities, but very good beginner
collectibles, and many models can be picked up for $15 to $45, with
little haggling!!

CARLTON VIEW. These are large and cumbersome, like all view
cameras, many feature brass metal work. Prices vary: $50 to $110,
little more for the rare (but hard to re-sell) 11 x 14 inch monster!

EMPIRE STATE VIEW. Like above — values, $60 to $125.

CYCLONE. Box type cameras, mostly 4 x 5 inch size. Most have top opening lid. Values, $25 to $40.

GEM POCO. A simple-design but seldom seen box model. Prices vary, $35 to $75.

HANDY. This is another big box, many have side-opening door for film loading. Valued at $30 to $70.

IDEAL VIEW. From 1895 or so. Values, $45 to $90.

NEW MODEL. Yet another view camera. Prices: $55 and up.

POCOS. Many variants of these folders. A Pocket "A" used 2 x 4 cut film, rarer than some: $70 to $145. A 4 x 5 film model is more common: $25 to $65 most varieties.

CYCLE POCO — many with red bellows, cowhide over thick wood bodies. Prices encountered: $35 to $60. I have heard of, but never seen, a **TELEPHOTO POCO**, with special lenses, values, $65 to $120. There is even a folding **GEM POCO**, at around $40 and up. AND — behold, a **POCKET POCO** at $25 plus, while an "A" model uses larger 3 x 4 film, rare at $65 to $110.

PREMO AND PONY PREMO. These are the ones I mostly find — I've bought and sold over 10 of these in the last few years! They are:

PREMO FOLDING. Coming in various sizes, marked by a number like Kodak, increasing numbers mean larger film size. From my Premo No. 3 at $25 in 1979, I've found these drop-bed folders with red bellows, Kodak lenses, Bausch & Lomb lens, and a few VERY nice models with lens by Zeiss! Most will have air-cylinder shutters, often brass-plated. From 2 x 3½ inch roll film, these go up to 3 x 4 film, and some 4 x 5 models — the Premo was a sort of bread-and-butter model for Rochester, along with the cheaper Ponys and Pocos! General Values: $20 to $40 to $60, depending on condition and quality of lens fitted. My size 5 x 7 Premo was bought for $35, but because this size is rarer than most, it went for $70 at consignment in a small antique shop!

PONY PREMO. Models vary by number: "3", "4" and "5" and so on. Mostly air-cylinder (pneumatic) shutters. Again, very wide in value: $30 to $70.

PREMARET. A rarer box model, usually 4 x 5 film: $65 to $110.

PREMIER FOLDERS. An earlier (1894?) model folder, nice looking. Prices encountered: $45 to $100.

Other Stereos. Rochester made several stereos; like all this genre, they're rarer than the ordinary folders, but less valuable than the prestigious Graflex and Heidoscop and Richard and other French and

German models. Appearance and condition important as always. Prices, $90 to $140 to $175, more for case or Mint condition.

Rochester made a few short-run or poorly-selling models. I can only offhand, think of the all-wood **CARLTON TWIN-LENS**, circa 1893. Don't hold your breath: This Rare Bird goes for $230 and up when found!

ROLLEI CAMERA CO. (Frank & Heideck, Braunschweig, Ger.)

The **ROLLEICORD** and **ROLLEIFLEX** have got to be the greatest twin lens-reflex cameras of all times . . . and they're affordable! I have owned over 10 of these cameras, and have shot excellent pictures with every one of them. Other twin-lens brands are rarer (the incredible Contaflex), and cheaper (the Ciroflex and Yashica "A" to "D" and Voigtlander Brilliant), but none really represent this design of camera like the Rollei. Even today, 50 years after their introduction, modern cameras like the Yashica Mat 124 and Chinese Seagull are still imitating the Rolleiflex!

Today, Rollei makes 35mm cameras and a 110-size miniature i collectible. But the twin-lens Rollei will be collected and used daily b photographers, I will predict, right into the 21st Century! They're tha good.

ROLLEIFLEX of 1929. This model used 117 film, had a rim-set Compu shutter, and serial numbers below 200,000. Rare. Value $110 to $180.

ROLLEIFLEX 1932 and 1937 versions. These are more common, with early models sporting 1/300 shutters, like 1929 version, and later, to 1/500 second. The '32 model has a single lever for cocking and releasing the shutter; later models have separate shutter. A ruby window is on the '32 for setting first exposure, eliminated in 193 model. Either can be priced from $40 to $80.

ROLLEIFLEX, 1939. Ruby window in some models, as '32. Small lever set shutter speed and lens opening, which show in tiny windows Serial numbers above 800,000. Value $45 to $80.

ROLLEICORD I AND IA. These 'cords are slightly cheaper versions o the Flex, have 1/300 shutters, and knob film advance, '32 and afte 'Flexes use a wind-lever. The early "I" model has an "Art Deco" front Values range: $45 to $100 for a perfect Art Deco 'Cord with case.

ROLLEICORD II. Made from 1938 to 1950, the II still has the lesso quality Triotar lens that all previous Cords use, but now has flas sync, and a bayonet mount on the lens, for filters and close-u lenses! Some models equipped with Xenar lenses — much bette than the Triotar. $45 to $70.

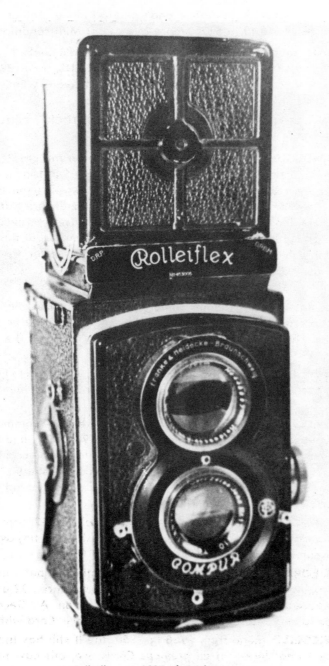

Rolleiflex, ca. 1937, $40 - $80

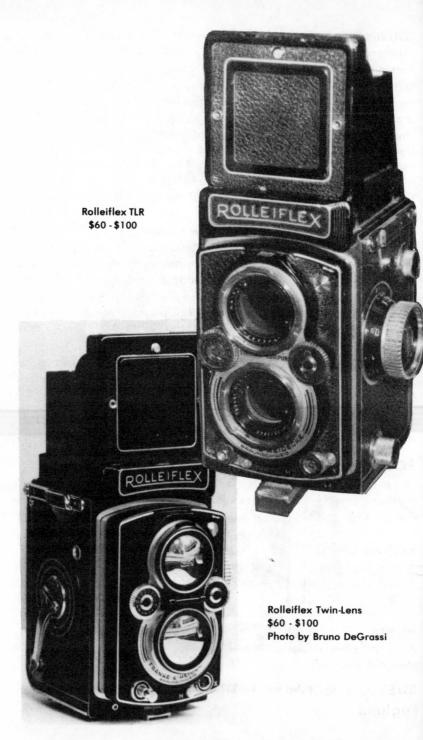

Rolleiflex TLR
$60 - $100

Rolleiflex Twin-Lens
$60 - $100
Photo by Bruno DeGrassi

ROLLEIFLEX 1950 model and **MX** version. These two are often encountered. Serial numbers up to 1,427,000. Most are found with the Xenar lens. $60 to $100.

ROLLEICORD III to V-A. These models, including the IV and V, are steady improvements on the earlier models. Serial numbers go up to the V-A at 1,940,000. The model "V" has an LVS system, so that shutter and lens are inter-locked until disengaged, for 'light-value' figuring of exposures. This was not a popular feature, otherwise, these models are similar to all Rolleis, except that the V-A can accept a 35mm replacement back called the Rolleikin. Also, the V-A has the focusing knob located on LEFT side of camera. Prices encountered: $60 to $80 to $100.

ROLLEIFLEX F 2.8. These 1950 to $959 models used a fast F 2.8 lens. The F 2.8 E and F 3.5 E Planar models have a built-in exposure meter! The F 2.8 or F 3.5 Planar lens is a fantastic performer, and so these models are sought as useable, modern professional cameras! Various other improvements tag these modern Rolleis in the $125 plus range for F 2.8 Tessar, up to $300 plus for the F 3.5 Planar. Big-City store prices nudge $500 in perfect shape!, (F 3.5) to $550 plus for the F 2.8 Planar!

ROLLEI 4 x 4. From the 1930's into the 50's, some models of the Rolleiflex were made to take 127 (or 4 x 4 cm) film. The pre-War models sell for $135 plus, while the 1957 model ranges from $110 to $160! Lens is 60mm Tessar.

See Heidoscop for the Stereo Rollei, ca. 1929.

ROSS of London
This firm made several Twin-lens-Reflex models around 1896-1900 or so. Heavy wood bodies, various lenses. These are VERY rare, would sell for $280 to $540.

ROYER SAVOYFLEX, from France
A Post-World War II single-lens-reflex, with leaf-shutter. Mediocre workmanship, but fairly rare. Values, $35 to $60, more for Mint and case.

RUBIX
A small 16mm viewfinder camera, ca 1951 from Japan. Fair workmanship and quality, rarer than Hit. Values vary: $35 to $70.

RUBY and RUBY SPECIAL . . . see Thornton Picard of England

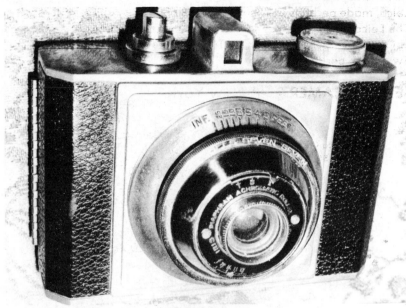

Rolls "77", $15

SANDERSON of London, England

Known for impressive view and hand-stand cameras. Most in America are the bellows-folding models for 3 x 4 and 4 x 6 size of film. Prized are natural-wood finish Tropicals, but these are very rare, often sell for $450 plus, more for Mint condition and, say, Goerz lens, etc. I've seen leather-covered models in Good to Very Good shape go for as little as $220. Look for touches of quality like red bellows, 'fast' shutter speeds in the leaf shutters. Ross lenses are better than most Becks, etc., Zeiss Tessar better yet, etc.

SCOVILL CAMERA

Merged with Anthony to form "Ansco". Most-encountered are the detective-box cameras, the **KNACK** and **WATERBURY**, from ca. 1892 to 1900. These are well-made leather-covered boxes, much rarer than 20th century 'detective' models from bigger firms. Values average $380 plus, depending on condition. A **MASCOT** box can hit $330 value, stereo models $280 to $340.

SEARS & ROEBUCK

For the **KEWPIE BOX**, See Conley camera. "Tower" was a trade name, and after World War II, many designs were sold using this name, including 35mm view-finder candids, boxes and a Tower twin-lens reflex. These were made in Germany and Japan, with the Tower

name slapped on. The best Tower was a Japanese 35 copy of the Leica, made perhaps by Nicca Optical, or another Japanese company. The Leica-Tower sells for $80 to $130. It is not as good in workmanship as the Leotax or Honor. Tower boxes sell for $5 or so, the Twin-lens, perhaps $20.

SENECA CAMERA of New York

Seneca Chataugua
$25 - $50

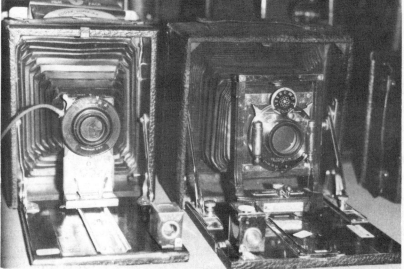

Left: Seneca, $15 - $25. Right: Seroco, $35+. Photo by Bruno DeGrassi

The various folding, drop-bed models of this company are often encountered, usually in lower-priced models with black oilcloth bellows, simple lens and shutters, etc. Models were designated by number, with the very common **CHATAUQUA** model prominent.

A **UNO FOLDER** is of simple design, can go for $15 to $25, while the various folding models range from $15 to $35, with 5 x 7 models a little rarer. I've bought and sold Chatauquas from $20 or so, while some ask $80 more!!

VEST POCKET and similar models have a lens standard that pops out on slender metal struts, like some Ansco models. These are also often seen, vary in value: $20 to $40.

The **SENECA STEREO** is rare, has sold for $100 to $185. A **BUSY BEE** is common, at $55 plus.

SEPT

This French-made 35mm camera was a combined movie camera, that took single shots, and could be combined with a factory-made light-source for projecting positives! Heavy, all-metal camera is moderately rare, often found with inoperative shutter. By Debrie of France, circa 1920's. Values range: $30 with mechanical problems, up to $165 in Mint shape with case.

SHAW OPTICAL

The **LEOTAX** is a well-made Leica copy, in various models from the 1950's. Focal-plane shutter and interchangeable lenses like the original. Values, $70 to $125, more for later models with flash sync and self-timer.

SHOWA OPTICAL, Japan

The **XIT** is the only model I know, from the early 1900's. The lens standard is held between twin wooden 'arms'. For plates and cut-film. Rare. $110 to $230.

SOLIGOR TWIN-LENS-REFLEX

From the 50's. A mediocre-quality model from Japan, using 120 film and flash sync. $40 plus.

SPARTUS

Several models of cheap, simple-design cameras came from the Post-War II company. This line followed the Falcon Camera Co. products — perhaps made by the same sub-supplier? a 127-film Spartus goes for $5 to $15, while some models had a large built-in flash reflector — value, $10 to $15. I've heard of, never seen a simple-design twin-lens with no focus.

STECKY

A fairly common 16mm sub-miniature from Japan. This 50's model was made in I and improved II versions. Prices: $15 to $35.

STEINECK

This was a sub-miniature made in the shape of a wrist-watch. From Germany, ca. 1949. Rare. Valued at $280 and up.

C. P. STIRN, N.Y.

This company made several very rare box-type detective cameras, that usually sell for over $500! The best-known Stirns is a "Vest pocket", round, all-metal camera that could be concealed beneath a man's vest, with tiny lens peeping from a button-hole. The single-speed shutter exposed onto a glass plate, advanced in rotation. This 1890 or so model is also rare, at $700 plus.

TDC COLORIST STEREO

These are often encountered, German-made 35mm cameras, made in "I", "II" and Stereo Vivid models. The original is a view-finder, the "II" has a rangefinder, and the Vivid has respected but unique mechanical features similar to the Viewmaster Personal. Metal bodies and good workmanship mark these, with glass, 3-element lenses. Most American stereos, like TDC, go for $85 to $140 with case, Mint. Look to shutter performance; not all camera repairmen want to tackle stereos!!

TDC Colorist, $85 - $140

TANACK

This Japanese range-finder is another Leica copy, not equal in quality to the Honor, but better than Russian copies. Some models have flash sync. Values range: $90 to $130.

'TAVI-IV' CAMERA

Made by Walker Manufacturing of New York from ca. 1900. A unique film-holder gave four exposures on a glass plate. Very rare, at $900 plus.

TESSINA

A very well made camera for 35mm that is extremely compact, can be worn on the wrist, and is reputed to be the camera used by the Watergate 'burglars'! A spring-winding motor advances film. Shutter, 1/500th second. Valued at $150 to $230 in Mint with case, filters.

THORNTON-PICARD

These are well-made single-lens-reflexes from England, made from late 20's into the 1940's. Cloth, focal-plane shutter is rugged, set by one dial, but expensive to repair. Many lenses found, best, my opinion are the Dallmyers and Goerz and any Zeiss models. The 2 x 3 inch film model is popular, bigger models less so — a 120-film roll back would add greatly to any example of this camera. Values: $50 (sticky shutter and torn leather), up to $200, Mint with roll back, perfect shutter, and case.

There is a Tropical seen occasionally, in natural finish Spanish Mahogany or even Teak, for $1,200 plus!! Stereos show up time to time for $400 plus.

Thornton - Picard, folding plate view
camera, English made, ca. 1890
Courtesy, John Groomes

TOM THUMB

This was a bulky radio-camera, from around 1940, and rare. Prices: $55 to $130.

TOURIST MULTIPLE

This is very rare: a 35mm camera made by "New Ideas" of America around 1915! This pioneer camera used 50-ft. rolls of cinema "35" film, with a good shutter and various lenses, including Zeiss patents. A high initial cost and the First World War scotched this promising design, now they are prized collectibles at $1,700 to a little over $2,000! A carbon-arc projector attachment and its case would add much to this!

TOWER . . . see Sears

TRI-VISION

Plastic bodied stereo used '628' film, from Haneel Co. of California about 1946. Valued at $60 and up.

TYLAR of England

Another wood-finish 'detective' box camera, simple shutter and adjustable lens aperture. Rare, at $250 to $295 or so, more for "disguising" cowhide case.

TYNAR

This 16mm rectangular camera, circa 1950 is more common than many sub-miniatures, features adjustable lens and shutter, with tiny yellow filter enclosed in leather case. Prices encountered: $15 to $30 to $40! I've heard of, but never seen, a little telephoto lens, that is an accessory for the Tynar II . . . add $15(?) value.

UNIVERSAL CAMERA, New York City

This small company made many models in the era 1938 into the late 40's, the most famous **IRIS** and **BUCCANEER** and **ROAMER 120** and the incredible **MERCURY**, with a metal rotary shutter and "half-frame" exposures — 24 x 18mm or 46 exposures to a 36 roll!

UNIVEX A AND AF2 and **TWINFLEX** . . . these were 40's candid, simple cameras, the Twinflex, a TLR design. These used a special "00" size of film, which was abandoned in the Post-War II market. Values hover around $10 to $30.

Univex 8 mm
Movie Camera,
$15+

Univex, Mercury II, Model CX, ca. 1940 - 1950, $25 - $50

Univex Iris
$15

VITAR AND BUCCANEER. These two are plastic-bodied 35mm models, with bodies that look very much like the Argus A and Falcon Candid and other small-time competitors. A pop-out tube holds the lens and shutter, the Buccaneer has a peculiar exposure meter (extinction — squint at the numbers) and metal plate 'exposure calculator' on back of the body. Lenses are 'soft' and shutters poor in quality. Early models use that darned "00" film, later, standard "35" cassettes. Prices range: $15 to $30.

ROAMER. A 120 roll film folder. Value, $15 or so.

IRIS. All-metal viewfinder 35mm candid. Value, $15.

STEREO-ALL. I've never seen one, rarer than other Universals, but simple in design. Used 35mm film, plastic body, fixed focus, from the 1950's. Values, $40 to $65.

MERCURY I AND II. From 1940 or so into 1950. The "I" used special film, and suffered from shutter 'bugs' and mediocre workmanship. Value, $30 to $50.

The better Mercury II, 1949 and on, used regular 35mm film, so it had a re-wind knob atop the body, and a tiny milled wheel for focusing, and hot-shoe for factory flash kit. Two lenses fitted, the F 2.7 is rarer than the F 3.5; neither are prize-winners! A rare 100mm replaceable lens is rumored, with viewfinder. The "II" is mechanically superior to "I". Values, $25 to $50. If you go for a Mercury, check shutter operation carefully!!

VOIGTLANDER of Braunschweig, Germany

ALPIN FOLDER, ca. 1915. This is the oldest Voigtlander model I've ever seen, very well finished, and rare. Values, $100 to $125. Has horizontal format, unlike later folding models.

AVUS AND VAG. These are vertical folders, with wooden leather-covered bodies; the Avus is the better of the two. Vags sell for $15 to $35. The Avus has vertical and horizontal movements of the lens standard, like Kodak's Recomar. Values — $25 to $50.

Voigtlander Roll-Film Folder, 1920's, $15 - $25

BERGHEIL. This folder has little refinements, like twin fluid levels, to help with precision tripod shots. Many Bergheils have green or orange colored leather bellows, and even silver-plate hardware! Lenses are superior Skopars and Heliars. Values are really based upon rarity and eye-appeal — not mechanical features. Prices: $180 to $255.

BABY AND REGULAR BESSAS. These viewfinder folders use 120 roll film, many have tiny, yellow filters attached to the lens front. Skopar lens is superior to Voigtar. Pre-war models: $35 to $80.

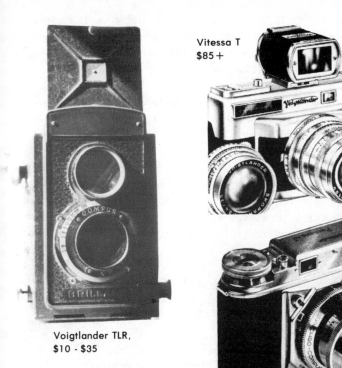

Vitessa T
$85+

Voigtlander TLR,
$10 - $35

Voigtlander Prominent,
35mm, $95+

POST-WAR BESSAS. Now we find little extras like frame counters and paralex-correcting viewfinder! Prices average $45 to $85.

Range-finder Bessas. From 1939 into the 50's, this was a quality product, rivaling the cheaper Zeiss Ikontas. Values, $75 and up. The very fine **BESSA II** has flash sync and often top lenses like Skopar and Heliar: Values can go from $100 to $200, last with the excellent Apo-Lanthar lens. A 1959 Bessa II in perfect condition with case could hit $310.

VOIGTLANDER SUPERB. This 30's vintage twin-lens used horizontal film transport. Its peculiar design features make it rare. Value, $115 to $155.

1932 PROMINENT AND VIRTUS. These 120-roll film folders are rare, seldom seen. The Prominent had a bizarre appearance, built-in extinction meter, did not sell well. Prices I've encountered: $200 to $500! The Virtus is more conventional, smaller and lighter than the clumsy Prominent. Values, $110 to $185.

STEREOFLEKTOSCOP. Also rare, has waist-level viewing through a center lens. This little 3-eyed wonder can be purchased for only $140 to $195!

BRILLIANT AND PERKEO. These two more affordable models use 120 film, the Brilliant is a twin-lens-reflex; the Perkeo is found in mostly viewfinder models, with a rarer rangefinder sometimes encountered. Brilliants run $10 to $35 in value, while Perkeo folders sell for $20 to $50.

VITO. This 50's vintage "35" is more modern, came in 3 models. Usual shutter malfunctions of candid cameras plague this model, but they are affordable at $10 to $25! A **VITO III** with F 2.0 Ultron is prized, at ca. $100 plus.

Voigtlander **PROMINENT 35.** An excellent camera made in "I" and "II" models. Lenses are F 3.5, F 2.0 Ultron, and a F 1.5 Nokton! Watch for the Compur leaf shutter to lag at slow speeds. Prices vary widely — $95 to $140 plus. Later versions have rapid-wind lever, and bright-lines in rangefinder. Look for bayonet-changeable lenses from 35mm to 150mm Dynaron — a full kit with extra lenses sold recently in New York for $350!!

BESSAMATIC. These leaf-shutter Single-lens-reflexes have inter-changing front components, and 1/500 second Compurs. Some have built-in meters. Values, $70 to $130. The sharp F 2.0 Ultron is preferred.

VOIGTLANDER VITESSA. These are my favorite models. They came into the 50's and up to 1959 in "L", "T" and "N" versions; the "N" is a cheaper 'wind-up-the-series' version. The early model and "T" had standard Compur shutter, paralex-compensating rangefinder, and all had a top-mounted plunger that advanced film and frame counter and cocked shutter in one stroke! The lens and shutter pop out from side-opening clamshell doors. The "L" model had a built-in exposure meter, and that darned 'Light-Value' (LVS) coupling system! Lenses do not interchange, but range factory fitted from F 3.5 Skopar (original and "N" models) to the F 2.8 Color Skopar and F 2.0 Ultron. A bread-and-butter F 3.5 Vitessa would be valued at $85 and up, while Color Skopar adds value, to $100, while and F 2.0 Ultron equipped "T" with case and flash could reach $140 in perfect condition. Avoid stuck shutters — my own Vitessa cost me $79 to fix in 1980, and I only paid $45 for it at a seedy pawn shop!
Note: Later Vitessa T models have no barn doors, value $85 and up. BUT this doorless model has interchangeable lenses, bayonet mount! Options are a nice 35 and 100mm lenses, matching separate finders.

VITRONA. This was not a success, featured built-in flash. Shutters usually kaput, like many 60's horrors. Value, $25 plus.

VOKAR

This American firm made a pre-war I model that was a disaster and a 1946 "II" version that ironed out most bugs, but couldn't live down the Vokar reputation. A very pleasing stream-line design had a rangefinder and 1/300 leaf shutter of cranky disposition. The Vokar is known for ripping film to shreds, but it is rare, so values range from a $25 example I picked up in 1979 to a Mint condition model "II" I saw recently with a $80 price tag!!

VOSS of Ulm, Germany . . . see Diax

WELMY, made in Japan

Various models were made by this small firm, which sought to design their cameras to resemble German models, even to their choice of name: "Welta — Welmy — Wirgin" — notice?

The Welmys use 35 and 120 film, usually show up with rusting bright-metal and sticking shutters, are pretty common. Prices encountered: $5 to $12 to $30 with case.

WELTA CAMERA of Germany

The **WELTA** and **WELTINI** are viewfinder and rangefinder 35mm cameras, respectively. Various lenses, including Steinheil and Zeiss, the Tessar F 2.8 is best, the F 3.5 is more common. Fairly common, mediocre in workmanship. Weltas valued at $30 and up, the Weltinis at $35 to $50.

The **REFLEKTA** is a cheaply-built Twin-lens-reflex that is often seen, goes for $20 to $30.

A **PERFECKTA** and **SUPERFEKTA** were both better-quality Twin-lens models with Compur shutters, made in small quantities and rare today, at $230 to $500!

A **WELTUR 120** with rangefinder is prized, at $60 plus.

WESTERN MANUFACTURING of Chicago, Ill.

From the 1890's, many box cameras for glass plates or cut-film in separate magazines were made, in models "1", "2", "3" . . . up to no. "5". "Cyclone Sr. and Jr." used separate double-side plateholders. I've never seen a folding model of Western camera! Rochester bought Western around 1899.

CYCLONE SR. OR JR., value about $25 to $30.

MAGAZINE CYCLONES, differing sizes of exposure, variable Waterhouse stops, simple shutters: Any, $30 to $50. Fairly common, good beginner collectible!

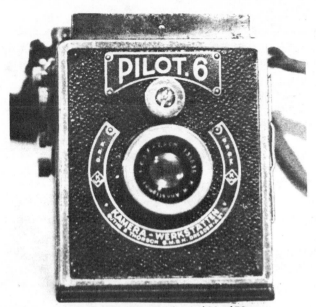

Kamera - Werkstatten, Pilot 6, $30 - $70
see Guthe & Thorsche

DAVID WHITE of Milwaukee, Wisc.

This 1950's company did not ever make a camera, but imported models from Germany, like Sears did for many of their Tower models, and others. A couple of 35mm viewfinder "35s" were marketed, value today around $25, but this company is known for their Stereos:

ST-41. From 1947, this well-made "35" Stereo used "D. White" lenses, or Ilex Paragon, shutter speeds to 1/150th sec. Boasted rangefinder, and hot-shoe flash sync. Value today, from $95 to $150.

ST-42. Now, 'faster' F 2.8 lenses were fitted, including the excellent Kodak Ektar, otherwise similar to above. The ST-42 would go today for $100 to $155, top price for Mint with case.

REALIST 45. This looks like the Illoca Stereo, with F 3.5 lenses, and only viewfinder, but retains hot-shoe flash. Prices vary: $85 to $130. As with all Realist stereos, look for filter sets and factory flash.

There is a very rare **MACRO REALIST**, made in small quantities, focuses to around 4 inches! Unusual design, and goes for over $400 in only Very Good condition!

WINDSOR STEREO

From Japan, circa 1953. Plastic body, and mediocre quality. Valued at $45 and up.

SIMON WING of Massachusetts

Mr. Wing was an early inventor, called a genius by many, whose unique cameras never sold profitably; he died in poverty, passed by manufacturing and marketing 'wizards' like George Eastman.

GEM. This all-wood camera from 1900 used a single lens with attached finder that moved in a pattern, via sliding wood panels, over a single plate, to give 15 exposures upon one 5 x 7 surface! Very rare, at $500 to $800!!

WIRGIN of Germany

Wirgin Folder, $15 - $25

EDINEX. Two models — one for "35", another for 127 film. Small, compact viewfinders, valued today at $20 to $45.

Stereos — called by **EDIXA** and **WIRGIN** names. Models included IA", "IIA", "IIIA" with built-in meter, and a viewfinder "IB". Watch for defective shutters! Values vary: $50 and up for viewfinders, to $75 plus for R.F. "IIA", up to over $100 for metered and MX flash "IIIA"!

DIXA 16. This late 50's sub-miniature is of medium quality, later models have built-in meter (usually not working. Values today, $40 to $55. Not in the same league with Gami and Minox III.

Wirgin Edinex, $20 - $45

In the 1950's, Wirgin made a twin-lens-reflex of so-so quality, today going for $30, and an often-found Single-lens-reflex that is cheap, and marked by poor workmanship, and a shutter that sticks at the slightest provocation! I've bought and sold Edixas for $20 to $45.

WITT ILLOCA of Germany

Some 35mm cameras were made by this firm, not rare, value to $30. The stereos are best known — a first model, a "II" and a **RAPID**. The last used F 2.8 lenses, and a rangefinder. Value, $175 or so for Rapid, down to approximately $100 or so for the others.

WITTNAEUR

Made in Japan, various models were marketed in the 50's and early 60's; nothing special. Values for "35s", $20 or so, with a Wittnauer 16 seldom seen, at perhaps $30 plus with case.

WOLLENSACK

This famous lens-maker made a heavy, well-finished Stereo in the 50's. Lenses, F 3.5 or F 2.7, in MX flash, 1/300 sec. shutters. Rangefinder has limited parallex correction! Values range: $95 to $150, Mint.

Wollensack Stereo, $95 - $150

YASHICA of Japan

From the 60's, the **RAPIDS** and **SEQUELLE** were made for 35mm film, for half-frame, or 24 x 18 exposures. Moderately rare, at $25 to $45.

The **YASHICA 16** and **AUTORON** both used 16mm film, quality inferior to Minox, at $20 to $40.

A **YASHICA 35** styled like Leica and with focal-plane shutter shows up now and again; medium rarity at $90 to $130, Mint with case.

The best-known Yashicas from the pre-Single-lens-reflex era are the Twin-lens models, called "A", "B", "C", "D", "44" for 127 film, and early **YASHICAMATS.**

Quality moves up as letter progression, from values of $20 for a Good "A" to $85 or so for a Very Good "C" or "D". The "44" has gained in value recently, can sell for $60 to $100.

The "D" and YashicaMat are more good, used cameras than real collectibles; the 'Mat sells often in pawn-shops and city stores for $90 or a little more. The Yashica 635 is a Twin-lens that has a kit to fit 35mm film, like later Rolleicords! The 635 can go $50 to $95.

Avoid Yashica TLRs with built-in meters; they are not particularly rare.

ZECA of Germany

Various folders of conventional design, vaues $20 to $45.

ZECAFLEX. Very rare twin-lens-reflex, 1937. $350 plus.

Zeca German cut-film camera, ca. 1929,
10 x 15 cm
$50 in excellent condition

ZEISS of Germany

This is the giant of European camera makers. They bought up Goerz
Ica, Contessa-Nettel, Ernnmann in 1926, made many of these model
under Zeiss-Ikon logo.

ADORO. Folder for 6 x 9 cm plates, late 20's. Value, $25 plus.

BOX TENGORS. Several different models, Baby Box with simpl
finder, 127 film, value about $30 to $45. Others have small refle
windows like American boxes, use 120 and other films. Value
average $25 to $40.

CONTAFLEX TWIN-LENS-REFLEX. This classic was made in small numbers around 1936. For 35mm film, this heavy, beautifully constructed Twin-lens featured interchanging lenses, a focal-plane shutter to 1/1000 second. Very rare, value from $600 to $900. Additional lenses are very rare, also, collectible in themselves.

CONTAFLEX SINGLE-LENS-REFLEX. These 1950's single-lens models used leaf-shutters behind the lens. Early models were common, while some later models have interchangeable front components on lens, and the "S" model has a built-in light meter. The "S" can go for $125 plus, while others would sell for $60 to $80. A Contaflex "IV" and Beta and Super all have exposure meter, while a 59 Rapid had a rapid-wind lever, but no meter! I'd guesstimate $100 and up for VG plus examples of these latter models.

CONTAREX SINGLE-LENS-REFLEX. From the early 60's, this was a deluxe model, with odd-looking bulls-eye meter window above lens. Featured rapid-wind lever, interchangeable finder screens. Superb F 1.4 lens is prized. The Contarex was too costly, could not compete with Japanese SLR's — now, a heavy, collectible classic. Value, $205 to $300 and up, more for fully interchangeable lenses and case, etc.

CONTAX I. This first Contax "35" rangefinder from 1932 was made in 5 variants that I know of — first model had a small dimple beside right-hand rangefinder window, and no 'shoe' on the tripod socket, so the camera falls down on any level surface. This rare model sells for over $490 in near-Mint, other variants valued at around $200 to $390! All "I's" finished in black enamel.

CONTAX II & IIA. These show refinements in design, same metal focal plane shutter as the whole series, and bayonet-mount interchangeable lenses. The "IIA", like "IIIA", has flash-sync. All "II's" and "III's" are chrome-finished. Lenses include a super-fast F 1.5 that is a disappointment below F 5.6, and a slower but sharper F 2.0 — the Contax I usually came with F. 2.8 Tessar. Values vary, often due to mechanical condition, especially shutters! — $80 to $150.

CONTAX III & IIIA. These are very similar overall to "II's", but have a large built-in meter. Like all Contaxes, the cloth ribbons holding the shutter segments together (like an old roll-top of a desk) wear out, and replacement can be expensive. The meters usually have worn out on these, too. Values about same as above, $80 to $140.

CONTAX S & D. These 49 vintage single-lens models from the East Zone were crude, poor in workmanship, but were the first with a built-in, eye-level prism! Focal-plane shutters, interchangeable lenses. Also called Hexacon, other names. Value, $55 to $90.

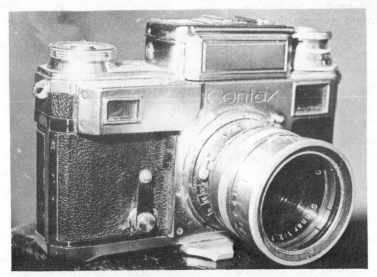

Contax III "35", $80 - $140

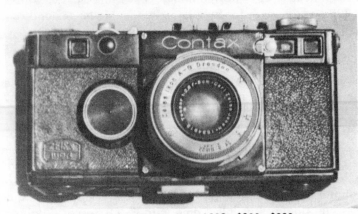

Contax I, Version I, ca. 1932, $200 - $390

Contax II - A
$80 - $150

CONTESSA & CONTINA. The 50's Contessa was a folding, 35mm camera with excellent rangefinder and Tessar lens. A minor classic, and very useable as a picture-taker. Value, $100 to $160.

In the 60's, both cheaper Contessa and Contina models, most with viewfinders, were marketed — marginal collectibles at best. $20 to $40.

DECKRULLO. A rare 20's folder with focal-plane shutter. $280 plus.

IKOFLEX TWIN-LENS-REFLEX. The Ikoflex "I" was cheap in construction, used horizontal film travel. Novar lens, simple shutter. Value, $50 to $100. The Ikoflex "II" and "IIA" were much better cameras, with Compur "II" shutter, and the "IIA" had a flash sync in later models. Value, $50 to $85.

The "III" was impressive; this '39 vintage model had a F 2.8 lens and 1/400 shutter and lever film advance (a trouble spot), while "IIs" above had knob advance, as did post-War II models of Ikoflex.

Both the Ikoflex I-C and the Favorit from the 50's had a built-in match-needle exposure meter. I-C with Novar lens goes for $50 or so, while Favorit with Tessar lens would value at $70 to $120, more for case, filters, etc.

My favorite Ikoflex is the 1956 "II-A" with a bright focusing screen and levers for setting lens and shutter and flash sync. I sold her for $50 in '79, and I'd pay $100 for a Mint one in a minute!

IKOMAT, IKONTAS, NETTAR FOLDER. There are many variations of these, only a Super Ikomat is rare, used a coupled rangefinder like Super Ikonatas. The Nettar is a low-priced model of the 30's, valued at $35 or so. The Ikomats and Ikontas all use 120 roll film, take 6 x 6 cm or 6 x 9 exposures. Values would average $35 to $45 for Novar lenses, $40 to $60 for Tessar lens, little more for 50's models with flash-sync. Combine coated Tessar and flash and Mint condition, and you might reach $85 plus in value.

SUPER IKONTAS. These are what the collectors want! The Super "A's" took 16 exposures on 120 film, and are rarer than some other models. Figure $125 or so for pre-War, and up to about $275 for coated Tessar, flash-sync models of mid-50's, more for Mint condition.

The "B" Supers are more affordable, at $100 average value — except for the Post-War "B" with F 2.8 Tessar lens, $250 plus, and a "BX" with F 2.8 AND built-in meter! Values hit $300 or so on these.

The C Super takes 6 x 9 cm pictures, have masks and Post-War models have flash. Early C's go for $70 to $100. The 50's "C" is a little rarer, can sell for over $200, with Tessar, more for Mint.

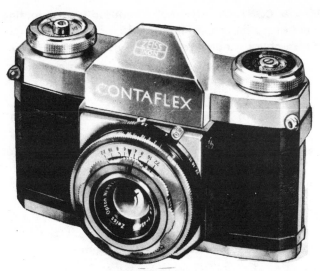

Zeiss Ikon Contaflex, Single lens reflex, $60

Zeiss Ikon Contaflex with
Synchro Compur

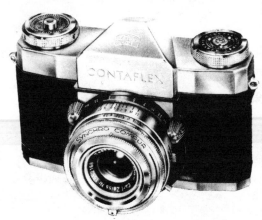

A "D" Super from ca. 1938 is high-priced, I don't know why. This 616 film folder has sold for over $300!

SUPER IKONTAS. There's a later 50's "III" and "IV" model; the "IV" has a built-in meter, and usable 'MX' sync. The "III" sells for $140 and up, while the light, pocketable "IV" is prized as the Last of the Line and can fetch $200 plus.

There are little touches that Ikonta-lovers look for on different models, like 'Albada' sportsfinder, and accessories, and double exposure warning, etc. Even Super Ikonta cases sell for $7 to $15 on the open market.

he rangefinders on Supers are unique in design, but usually rouble-free, and the Compur shutters are 'fairly' easy to fix, and the old-out side bracing is good and rigid. These cameras will likely hold neir value, and increase steadily, because most, with 120-film apability, are good day-to-day picture takers, too.

DEAL, MAXIMAR, NIXE, ONITO, ORIX, OTHERS. My favorite is the Maximar, but most of these are well-made, fold-down bed cameras, nostly for cut-film or plates. Many lenses fitted, but the best are F .5 Tessar (a rarer F 3.8 is nice), and because the lens and shutter nits are usually easily removeable, I've seen these leather-covered olders with Skopar, Voigtar and Novar lenses — only the Skopar is espected.

ve encountered a 6 x 9 Maximar in near-perfect shape, with a Heliar ens, 1/500 Compur shutter and roll-film back that sold in '80 for 110. Other models would sell for $80, down to $20 with sticky hutter, torn leather, etc.

KOLIBRI. The rare Kolibri is a compact 127 film camera. The F 3.5 essar is a good lens (value $175 plus), while a Night Kolibri with F .0 lens has hit $400 for Mint with case, filters, etc.

MIROFLEX. This single-lens reflex from the 20's used many lenses, ad a cloth, focal-plane shutter. Miroflexes sold well, were "dusted ff" and sold in big-city stores during the early Post-War years emember the 1946 'camera shortage'?). Good, solid cameras, the Miro sells for $140 to $230 depending on condition, especially that ard-to-repair shutter. (I'm not picking on the excellent Miroflex; MOST old, big focal-plane shutters are hard to repair or replace!) maller 6 x 9 cm model preferred.

ETTEL, SUPER MODEL. A well-made, unusual design folding camera or 35mm film, vintage 1935 or so. Focal plane shutter. Value $200 o $340 because of rarity.

PALMOS. The Minimum Palmos used a focal-plane shutter, the niversal Palmos used mostly 9 x 12 and 10 x 15 cm cut-film. The niversal had a tilting, rising and falling lens-board, would make a ecent studio camera for pro use with a coated lens and adapted 4 x inch film back!! The Minimum might sell for $85 up to $175 with ne Universal would go for $85 up to $205 with 'extra' front and rear eplacement lens elements, spare backs, etc.

PICOLETTE. The little Pico looks like our own Kodak Vest Pocket 127 odel. Various lens and shutter combos — best have a Tessar and 1/ 00 sec. shutter! Most will have cheaper lenses, sell for $40 to $60.

TENAX I & II. The Pre-War I is a fairly simple design 35mm ewfinder, sells for $40 or so.

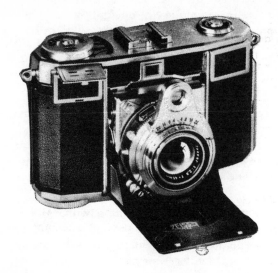

Zeiss Ikon
Contessa 35
$100 - $160

The "II" from 1940 had interchangeable lenses, including a F 2.0 Sonnar, and wide-angle and medium-tele lenses, and a 1/400 sec shutter. A lever beside the lens is pushed down to advance film, cock leaf shutter (this often is malfunctioning on examples found today). The Tenax II can use special cassettes, so you don't rewind film (avoids scratches). The II is rare and noted for fine workmanship, so value goes from $180 to $310 — but check shutter operation carefully on this one!

A 'modern' Tenax Automatic uses automatic exposure control, not really rare or respected — a marginal collectible at $20 to $30.

Lenses

Generally, separate and loose lenses you may find for sale will be: older 'barrel' lenses, that have no shutter attached, are large, designed for very old cameras, or may be "projection" types, to be used to project positive transparencies, or for opaque projectors. These lenses may or may not have a flange or mounting ring attached, and may have older Waterhouse stops built in, or (more modern) an iris between the lens elements inside, or — with projector lenses — often no aperture adjustment at all. I would avoid these, unless you have a specific use for them. Most of us are unlikely to have any use for projection lenses, and barrel lenses for camera use would only be of value on a focal-plane shutter camera, like the Graflex and a few others.

Brass lenses from around the turn of the century are pretty, and if you own an older camera you are sure you can mount these to, they'll add eye-appeal to an old lens-less camera, especially with red bellows, wood-finish on body, etc. Look for a rack-and-pinion focussing mechanism, Waterhouse stops, etc. But don't just buy one of these willy-nilly because it looks good; it might be hard to move. I purchased one last year for $20, and sold it later for $15 — I had no practical use for it, and few buyers did either!

On the other hand, a brass barrel camera lens made by Dallmyer, Goerz, Voigtlander, and VERY old lenses for wet-plate cameras by C.C. Harrison, Anthony, etc., might be worth a good price. Harrison is a historic, rare name from the late 1800's, but Anthony lenses might be hard to date, as many were made. Much study is needed in this area. A general rule is to inspect the glass carefully, (fogging, scratches, etc., or disintegrating glue around element edges), bid low, ($8 to $15 or so).

Aside from brass types, more common and modern barrel lenses were made by Cooke of England (good), Beck, also English (so-so), Kodak Anastigmat (very common), Bausch & Lomb, both domestic formulae and Zeiss patents, including Tessar (better than most Kodaks), Darlot of France (many grades, fair to Very Good), and modern versions of Voigtlander, Dallmyer, Zeiss, Goerz and better grades of the English Cooke and Ross.

Wide-angle lenses were designated Weitwinkel on most German products. Not all wides, however, are designated on English and American lenses!

On the whole field of barrel lenses, I would just advise caution. A LOT of study, mostly into the early history of photography, would be needed to date and value these kinds of lenses! If you can pick up a very nice condition Dallmyer or (Luck!) a C.C. Harrison for $20 or a bit more — DO IT, and research your find later at leisure.

More common, and useful are the lens-plus-leaf-shutter combinations, most dating from circa 1912, right up to the present day — most studio professionals use a lens with in-between shutter on their view cameras, that looks much like its counterparts of 70 years ago!!!

The same names as above show up again, with more varieties of Zeiss and Voigtlander, and American names like Wollensack (Good to Very Good) and Acme (so-so in my opinion). Most Zeiss and Voigtlander Weitwinkels are still prized for their usefulness, Agenieux of France, with Schneider's Angulon, are both respected brands, as is Krauss. Pre-World War Two lenses, of course, will be uncoated and flare-prone — suited for studio work, with soft lighting.

Lenses-in-shutters are also a 'special field', since their value depends mostly on their usefulness to studio artists, or that narrow band of collectors who love to buy older, rare and respected lenses and arrange them on their collecting shelves! Classic names are Dagor by Voigtlander, Apo-Lanthar, and wide-angle Angulons. The Turner-Reich Convertible is prized by some for its ability to change focal-length when one or more of its three sets of lens elements are un-screwed!

From a well-known trade newspaper:

"12 to 28 inch-focal length Turner Reich Convertible, coated, in a U.S. Acme shutter . . . $250.

300MM F 9.0 Apo Tessar (a rare and respected design, as are designated Apo-lenses) with older Compound (air) shutter . . . $300

120MM Goerz Leitmyer Wide-angle, in modern Prontor shutter with flash synch . . . $100

162MM F 4.5 Wollensack Raptar in Rapax . . . $125

75MM Super-Angulon (wide angle) F 8.0 in shutter . . . $400

240MM Tessar in Compound synch shutter, (only Very Good condition) . . . $125

90MM Wide angle Optar (American lens) in shutter . . . $90

6-inch Kodak Anastigmat (uncoated, old) in Compur shutter Excellent condition . . . $60

108(?)MM Wide angle Wollensack in shutter . . . $70"

Various lens-and-shutters show up cheaper, mostly Kodak, Bausch & Lomb, Wollensack, Acme and Ilex brands, all American, and many available in imperfect working condition — sticky shutters — for $20 and up! And sometimes shutters without lenses pop up, from $7 (old Kodak) to $29 (Acme with synch) to Mint Compurs with synch at $35 and up!!

Volute shutters are a type going back into the early 1900's in which air pressure and a complicated mechanism controls both aperture and shutter speed. I've bought and sold these rare oddities for $30 (1979 at a Lakewood meet) to $45 in New York. 'Air cylinder' shutters from the 1890's are nice to look at, not very useable, at $5 to $15. And in the 19th Century, a shutter made to be installed AHEAD of the lens, called the Packard, was made into the 20th Century, and is mildly collectible in itself, at $15 (barely works) to $40 (Mint).

More modern lenses were made to screw or bayonet onto the front of 35mm cameras. The names I know are the Zeiss bayonets for Contax range-finders, (Zeiss Opton and Tessar or Sonnar) and the Voigtlander Prominent options: Skopar and Ultron and Nokton), and the very rare lenses for the Kodak Ektra: 50mm F 1.9, and a F 3.3 35mm, and a F 3.5 90mm and an F 3.8 of 135mm. The Robot German camera had various lenses, Tessar, Xenar and Xenon. The Cooke lenses (bayonet mount) for the Bell & Howell Foton are very rare also (marked in "T" numbers!).

The Leica lenses are the most numerous and these would be a good course of study for 3 months or so at any college! In general, I'd like to skim across these as follows:

F 2.0 Summar for rangefinder Leicas — soft at most apertures, a mediocre lens at best, at $15 to $39. A rigid mount variety from the 30's is VERY rare, at over $1,200 in value. All others are collapsible, as is:

F 3.5 Elmar. This is the 'workhorse' Leica lens, a good performer for its day (at any but wide-open, that is. Like most 35mm lenses, the Elmar is best used in the F 5.6 to F 11 range). Elmar and Summaron wide-angle (35mm). From the $35 to $50 value of the 50mm Elmar, the wide goes for around $45 to $60, and the modern Summaron at $50 and up.

A very rare Elmax 50mm lens was fitted to early Leicas — I've seen these go for $500 and up (try $1,200 for Mint), while a F 2.5 Hektor was also rare, and go for less, but not by much. And how about an F 2.2 Thambar telephoto for portraits for $1,000 and up!?!

My own, more affordable favorites are the F 2.0 Summitar at $35 to $50 (collapsible), and the common 90mm, F 4.0 Tele Elmar at $35 to $55 or so. Of course, the teles are not much good without the multi-viewline finder that can sell, itself, for $25 to $50!

Other and rarer models include the 1950's Summicron and Summirex, and over a dozen other variants of these and other models. Leicas and their lenses can be a life-time study — and for some collectors, have been!!

There are other lens 'families': the Exakta was very popular, and a host of lenses were offered for unique, left-handed Single-lens 35mm. Respected lenses for this brand include the 35mm F 2.8 Zeiss Flektogon Automatic at $100 or so, and a 75mm F 1.5 Zeiss Biotar at $150+ — Mint for both prices. The Ekakta used a unique design of bayonet mount.

Nikkor lenses were made for other cameras in the 1949 to 51 period, and Leica-mount Nikkors are not rare, but good performers at $40 and up. But most Nikkors will be found with the Nikon bayonet-mount, and the all around best is the F 1.4, at $50+. I also like the 85mm and rare! 28mm models from the 1950s at about $60 to $120!

Among 'modern' lenses, avoid Schact, Meyer, Isco, Meritar, Enna and most Schneiders of any model, and most Japanese lenses except Nikkor, Canon and their Serenar, and the rare but quite good Zunows!!

When buying any lens, you have to hold the lens up to a strong light, and develop an eye for scratches, dirt, clouding, lens-glue edge separation, etc.! Don't buy a lens and end up with an expensive paperwight!

Accessories

Exposure and 'Light' meters are now part of the photographica collectors field, and where they were almost ignored, or sold in shoebox-fulls for $1, they are now coming into their own.

Basically, the earliest exposure meters were tables, employing sliding bars, pointers moving over charts, and even rollers that showed light curves. They were, in other words, rather like slide-rules.

Two scientists named Hurter and Driffield made an "actinograph" in 1889, and this very early meter was the first mass-marketed exposure meter. This English invention, which today, in case with instruction booklet might be worth $250, gave rise to others:

Sliding or turning cardboard discs could be turned, and some kept inside a case or diary — the Wellcome Photographic & Exposure Record was one such, from 1905 or so. Another 'disc' was called the Ilford, invented around 1892. Either one of these, being simple in construction, might sell for $5 to $15, depending on condition.

An all-metal meter that used pointers moving over an alloy plate engraved with numbers and values, came from France with the Posographe, circa 1922. This hefty instrument only has 6 moving parts, and so you may find one in working condition, just needing a little metal-cleaner! Because of rarity, the Posographe can sell for $35 up to $70, more for perfect condition and carrying case.

Most meters you'll find, used the principal that a series of smoked glass sections, progressively darker, might each carry a tiny number or symbol. If you viewed these, or turned one section over the other, you'd come to a point where you just about could not see anything!

This point— the extinction of light — was where they got the term 'extinction meter'. Many of these looked like tiny cylindrical viewers or miniature telescopes, and they competed with another type of meter called the Actinograph, or the Tint Meter.

The tint meter type, from the 1890s, actually used small samples of photo-sensitive paper, to hold up to the light. When, by noting your watch, this sample became completely dark, or as dark as a standard of grey you wished, you took the time in seconds or minutes, and transferred it to scales upon the instrument, for F-stop, exposure of shutter, etc. Though you had to have a sweep-hand to use them, these little meters were small and light and popular, and into the late 20's, they sold by the hundreds of thousands.

Early tint meters may be small tubes but most evolved into light, metal watch-case shapes. The most common are the Watkins, and their competitor, Wynne, both of England. The Adams firm of London brought out a more sophisticated model than Watkins, but it did not sell well, is rare today.

Extinction meters were made in large quantities in Europe, fewer in America. The Milner gauge is American, and rare, valued at $40 to $60. Others, like the Killfitt, might go for $25 plus, while a Mint Justophot or Eios from Europe could range widely: $15 to $30. Look for corrosion or cracked lenses, etc. Like all mechanical collectibles, it is not enough for the object to just be old — operating condition is extremely important, too — especially if time comes when you might want to re-sell!!

Don't confuse these 'real' collectibles with aluminum or plastic cased models which appeared during the 40s and 50s — look for brass construction, or nickel plate, and characteristic 'script' lettering, patent dates, etc.

Now, the Tint meters are fairly common, and over two dozen separate variants of both Wynne and Watkin brands were made, up into the 1920s! Some of these little watch-shaped gadgets were in silver or silver-plate cases! Names include Bee and Queen Bee and Infallible and Snipe.

A Tint meter by itself might sell for $20 in nickel-plate, less if it shows pitting or a dent, etc. Going up in value to silverplate cases, Mint condition, figure around $35 to $55. And with a factory box and instruction booklet and even refill 'disc holder, value could hit $80 or more, Mint condition for all!

A rare variety — a few brands of extinction, or 'actino' meters that were also made in watch-shape, though somewhat larger. These could be English or German in origin, and could bring over $100 in Mint working and appearing condition, with case.

Of course, today, the meters one sees of modern design use a small selenium cell to produce a tiny current of electricity. This selenium is activated by light, so as the sun's rays strike it, a pointer will move along a scale, to give 'light value' numbers. The user then matches these numbers up with the F-stop (aperture) and shutter speed he wishes to use. The most popular model is the American Weston, made in many variations from the late 1920s. Early models of Westons, and the very first General Electric, could go as high as $40, Mint with case. It is unlikely, however, that the over-worked selenium would still function very well after over 50 years!

Weston Exposure Meter, $10 average value

Sixtomat Light Meter $35+, working

Kelvilux color temperature meter, $30 - $60, working

Honeywell Strobona, Model 64B
$25+

Voigtlander Sun Shade, $7

Weston Light Meter
$5 - $15, older models

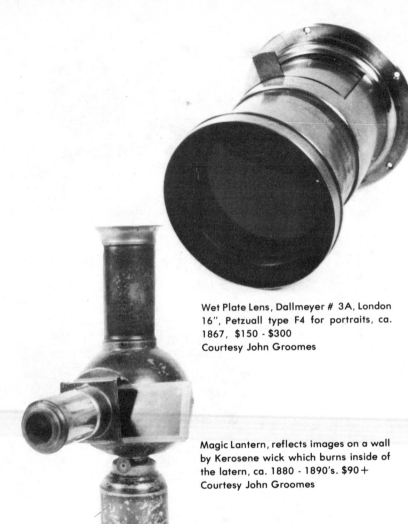

Wet Plate Lens, Dallmeyer # 3A, London
16", Petzuall type F4 for portraits, ca.
1867, $150 - $300
Courtesy John Groomes

Magic Lantern, reflects images on a wall
by Kerosene wick which burns inside of
the latern, ca. 1880 - 1890's. $90+
Courtesy John Groomes

KombiMeter, value, $7+

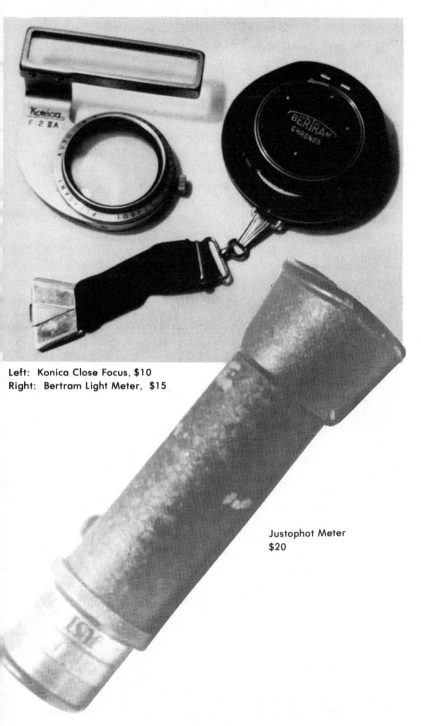

Left: Konica Close Focus, $10
Right: Bertram Light Meter, $15

Justophot Meter
$20

Images
Daguerreotype - Ambrotype - Tintype

In antique shops, one often comes across small cases containing images, and these may be various in price: From 50c for "tintypes" without cases, to scattered B&W (sometimes sepia or off-brown in tint) paper prints called Cabinet or Chamber portraits, and smaller (4 x 6 or so inches, vs. 2 x 4) Cartes De Visite Prints.

Older and usually more valuable are pictures made on silvered copper plate called Daguerreotypes and negative images made upon glass, this set over black cloth, or with back painted black, called the Ambrotype.

Now, what is this variety of images all about, and what does it mean to the collector?

The Daguerreotype is the oldest photographic image, producing an image without any negative directly upon the metal plate. These often show chemical change or oxidation around the edges, and change to a negative image when the picture is viewed at a slight angle.

The tintype is also a direct-produced image, often created in the camera body by on-the-spot application of chemicals within the light-tight body! Tintypes and mediocre-quality paper prints have been made and sold by 'street-corner' photographers all over the world for 70 years. Until very recently the success of the Polaroid camera has pretty much made this type of equipment obsolete.

The Daguerreotype appeared in 1839, and, because copies and multiple prints were not possible, this process dwindled out before the wet-glass-plate and dry-plate methods, (1852 and 1956 respectively) were introduced. Daguerreotypes are often found in faded condition, for they are sensitive to strong light and humidity.

The Ambrotype can also be used to create a paper-print, because it is a negative. Popularity of this type dated from around 1850 to 1862 or so, but as a 'specialty' method of photography, the Ambro, with updates in chemical process has continued into the 20th century, mostly in Europe. This is because, done carefully, the Ambro and its successors gives you an image undistorted by film curl (it's glass) and with quite fine detail, because in an Ambrotype, you possess the original image, undiluted by passing through an enlarger, or by re-printing! Of course, your ambrotype is heavy compared to a paper print, and it must be always kept in its case, with black backing, to protect from moist air.

Both wet-plate and dry-plate processes came into full bloom when paper-printing chemistry made it possible to get good detail by contact-printing. The wet-plate (or wet-collidion) process was widely

sed in the 1850s, but required an awful amount of equipment to be
arried by the photographer, since the glass plate must not only be
eveloped by applying fluids immediately after exposure, but the
icture-taker must sensitize the plate before the exposure by hand!

And even after the dry plates 'liberated' the photographer from
he drudgery of wet-plates, he or she must still be careful of
ght-leaks onto the plates, and process the exposed plates as soon
s possible after exposure for maximum clarity and contrast. And
ost 'pro' photographers of the period mixed their own chemicals
om dry powders and pure water, instead of using the ready-mixed
hemicals available to us today!

It is no wonder that, before the introduction of 'handy' roll-film by
odak in 1889, photography was a hobby for only a brave and
dustrious few!

Now, tintypes are really common, and because they lasted for
any years, are hard to date. I have heard of, but never seen,
ntypes by famous photographers like Mathew Brady and others.
ut because the tin-or-ferro-type does not really give very good
etail, and poor contrast range compared to glass-plates, the tintype
really an amateur or commercial process, used mostly for portraits
f 'everyday' people, vacationers at the seashore, or military men on
ave. These last would be the only valuable examples of tintype,
nd I've seen tintypes of Indians (usually shot AFTER the Indian Wars,
pon the reservations by wandering tintypists) that are valued, and
f course, like outdoor scenes of "period" buildings or whole land-
capes, like horse-and-feed stores, gold-mining camps, early loco-
otives and ships, etc., etc.

But, again, because the tintype was a 'Once-off' production, it was
ttle used for historical or commemorative shots, since extra prints
uld not be made, save by re-shooting the original (a poor result).

Mathew Brady shot in both Daguerreotype and Ambrotype and
ter paper prints, using the albumen process. (Yes, made using egg
hites!) His work starts (when you can verify by his signature or
amp) in the hundreds of dollars, since his time of fame dates from
e 1850s. But unsigned work by unknown photographers, even
om this period, is often inexpensive. My own collection of
aguerreotypes began in 1979, when I purchased my first lot, in Very
ood plus condition, for a lot of 12 in a shoe box . . . for $8!

As I mentioned, tintypes can go for 50c loose, to $1 for Fine
ondition, or of figures in ornate dress. Value is added if the subject
 a child in expensive dress, pushing a tiny doll's carriage, a boy
olding a toy or miniature pop gun . . . value $1.50 to $3.50 Mint
ondition.

Now, cases add a dollar or two or three to these values — often embossed oilcloth or very thin leather on a wooden frame, glass over. But most tintypes were not given this deluxe treatment, since they were usually meant to lay in photo albums, or even, like Carte de-Vistes, to be sent through the mail!

Generally, the subjects I mentioned earlier are prized for all photo mediums, whether tin, glass or paper print: Indians, Negroes, Eskimos, Military personnel (especially with guns!), ladies in very ornamental costume, theatrical figures, midgets or twins or triplets, and of course, any famous personality like former presidents, kings, etc., etc.

Figure low value for most tintypes (a little better for larger sizes, rare - like 2 x 3, 3 x 4 inches and so), and higher for Ambrotypes (the process did not last long in popularity), higher for Daguerreotypes since this is the very earliest photo process, and then, widely varying values for paper prints, since these can be easily reproduced, but — might be valuable if they are 1860s and so vintage Albumens, since from this era, the glass-plates have probably been lost or destroyed.

Adding to the earlier classifications, paper prints are valuable they are dated and authenticable, or if panoramic views (often printed in 6 x 13 and even larger sizes!), or well-detailed cyanotype (blue) or tinted in reddish or green tint or brown-tone (sepia).

Now, judgment counts in such things: Obviously, a panoram view of the blasted skeleton of the Hindenburg, or the remains of the R-101 (both dirigibles), or a row of aircraft at Floyd Bennet field, or some Davis Cup boats, would be a more valuable print than the graduating class of Partial Plate School of Dentistry in Saskatchewan (unless YOU happen to be a graduate of P.P.S. of D., of course!)

And combinations help — like a row of Union soldiers standing in front of an ancient locomotive, with an Indian guide among them!

Even more modern pictures can be worth something — Korea War vintage GIs standing around a Patton tank, — the home-coming parade in honor of Gen. Douglas MacArthur, etc., etc. And some buyers would be well willing to pay for a prize-winning speedboat with driver holding cup, or even a winning horse and jockey!

Of course, I remember one lady who purchased a panoram view in sepia of a Princeton graduating class for $1 and kept it on her shelf for many years. Luckily, she met an exceptionally honest dealer who tipped her off to its value, and in 1980, she sold it for $25. As you might have guessed, the print, in Fine condition, contained a surprise — Woodrow Wilson was among the graduates!

Another 'mere' snapshot was picked up in 1979 for 50c, and one day, a sharp-eyed dealer spotted it in a shoe box. The gentleman bought it, sold it that same day for $5 — because the barely

identifiable figure with bear-like sloping shoulders walking off the field was none other than Babe Ruth!

Let me give you some prices I've encountered:

Tintypes, small size (1¼ x 1¾ in.) 50¢ and up, with 1½ x 2¼ and 2 x 3 and up sizes, $1.50 to $3. More for unusual costumes, etc., etc.

Tintype of saw-mill, gold-mining camps, blacksmith shops, locomotive yards, etc. . . . $3 to $5 to $10! Beware of flaking at edges, bent metal, etc.

Daguerreotypes suffering deterioration, weak image because of light-damage, etc: $3, adding $2 to $5 for frames and cases, more or Mint condition. Add for subjects — soldiers, children with toys, etc.

Mint Daguerreotypes, unknown subjects, nice cases: $12 to $30.

Ambrotypes, similar to above, a little higher. Look for flaking of black lacquer on back, or other signs of image deterioration, chips at edges of glass, etc. Nice image, poor case: $12 to $20 — Very Good plus, case, undamaged, clear image: $20 to $35.

Often, Mathew Brady made Daguerreotypes and Ambrotypes of unknown subjects — but his studio name will be embossed onto the 'facing' surface, inside the cover door of the case! Don't buy any unmarked Daguerreotype, as a "maybe Brady"! And generally, don't buy a Daguerre or Ambro, with idea of restoring it — this is usually NOT effective, and only a few experts can bring any improvement to these images, and the investment is simply not worth it!

Paper prints vary so widely, I would not put any fast values on these: Develop an eye for subject, era, etc. — and remember that paper prints are easy to duplicate! I've bought cyanotypes of old teamships for $1, to see these later in cheap frames for $10 and up. And not every subject in buckskin with handle-bar mustache is Wild Bill Hickock!

As you develop your eye, you will notice features and details, in all pictures. Does that small boy hold a metal toy locomotive in his hands? Why, some lover of vintage and antique toys would probably buy that image in a minute!

And the gentleman in a 2 x 3 tintype — he is unknown, but he wears a beaver hat, and on each knee, holds one of twin girls! In fine condition, I would pay $3 to $6 for this, just for the visual appeal and age (beaver hats!?). And props or inanimate objects can help date — is the rifle our sharp-shooter holding a 18th-to-19th century Flintlock, or a Sharp's Repeating, or a Remington rapid-fire from the teens or early 1920s?

Is the paper print of a man standing before a high-wing monoplane just any aviator — or could it be Wiley Post, standing in front of the Willae Mae, before his fatal attempt to fly around the world in 1933?

Of course, with paper prints, you must be careful. I've bought pictures of Charles Lindbergh with his Spirit of St. Louis for $1 – because MANY thousands of these pictures were made and sold after 1927, some even given away in the early 1930s as a premium for products! And paper portraits of Franklin Roosevelt are NOT rare, unless authenticated by a famed studio — because over million portraits of Mr. Roosevelt were produced and printed after that great man died in 1945! — and millions more created by photogravure in countless magazines and newspapers.

I advise beginning collectors to buy carefully — don't speculate because you cannot KNOW when you'll meet a willing buyer. And study studio marks and imprints — don't gamble on unknown photographers or subjects. The word is caution, until you've carefully studied this wide and varied field!